Personal Choice

THIS BOOK HAS BEEN SUPPORTED BY
THE ASSOCIATES OF THE V&A

Personal Choice

A CELEBRATION OF TWENTIETH CENTURY PHOTOGRAPHS
SELECTED AND INTRODUCED
BY PHOTOGRAPHERS, PAINTERS AND WRITERS

23 MARCH – 22 MAY 1983

VICTORIA AND ALBERT MUSEUM

Published by the Victoria and Albert Museum, London
First published 1983
© Crown copyright – text
© Copyright of photographs: as listed in contents list

ISBN 0 905209 38 9

Designed by Patrick Yapp
Printed in Great Britain by Westerham Press Limited

FRONT COVER: *Nubile Young Beauty of Diamaré*, 1969
by Irving Penn by courtesy of Condé-Nast Publications ©

Contents

Bill Brandt
Photographer. Author of a series of books from 1936 to present. The most recent are: *Shadow of Light* (2nd ed. 1976); *Nudes, 1945–80* (1980); *Portraits* (1982). Among many honours Bill Brandt is a Royal Designer for Industry and an Honorary Doctor of the Royal College of Art

Bryn Campbell
Photographer, sometime picture-editor at *The Observer,* writer and presenter of *Exploring Photography* (BBC-TV, 1978). Author of many articles and *World Photography* (1981)

Sue Davies
Director of The Photographers' Gallery, London from 1971 to present; director of many major exhibitions and editor of catalogues; frequent writer on photography. Awarded the Silver Progress Medal by the Royal Photographic Society, 1983.

Ainslie Ellis
Writer. Columnist for *The British Journal of Photography.* Introduced *A Day off: an English Journal by Tony Ray Jones* (1974)

Harold Evans
Sometime Editor of *The Sunday Times* and *The Times,* author of *Pictures on a Page* (1978), director of Goldcrest Films.

Hamish Fulton
Sculptor who uses photography and the act of walking to produce image and text emblems commonly designated Conceptual or Land art. Author of many publications of his works since 1971.

32 CHRIS STEELE-PERKINS b. 1947 British
Ted, Market Tavern, Bradford, 1977
Ph. 880–1980
23 × 34 cm

34 JOSEF KOUDELKA b. 1938 Czech
Prague, 1968
Ph. 1442–1980
23·1 × 36 cm

36 W. EUGENE SMITH 1918–1978 American
Tomoko and Mother, 1972
Ph. 1052–1978
19·8 × 32·8 cm

38 MARIO GIACOMELLI b. 1925 Italian
Scanno, 1963
Ph. 878–1980
29·6 × 39·5 cm

40 MARTIN CHAMBI 1891–1973 Peruvian
Hacienda Owner and Workers, Chumbivilcas Region, Peru, 1945
Ph. 876–1980
32 × 42·8 cm
Printed from the original negative by Edward Ranney

42 SIRKKA LIISA KONTTINEN b. 1948 Finnish
Girl on a Space Hopper, Byker, 1971
Ph. 273–1981
25·5 × 17 cm

44 EDWARD STEICHEN 1879–1973 American, b. Luxembourg
Heavy Roses, Voulangis, France, 1914
Ph. 303–1982
20·3 × 25·6 cm
Photogravure by Jon Goodman, about 1980
© 1981 Aperture Inc.

46 TIM GIDAL b. 1909 German, lives Israel
Munich, 1929 (Hitler in a tea garden)
Ph. 434–1980
24·8 × 17·8 cm

48 JACQUES-HENRI LARTIGUE b. 1894 French
*The Beach at Villerville c.*1901–4
Ph. 308–1982
22·7 × 33·8 cm
Given by Olympus Gallery

50 U.S. NAVY
for Scott Polar Research Institute
Weather Conditions, Antarctica, February 10 1970
Circ. 542–1975
23·7 × 26 cm
Given by Scott Polar Research Institute, Cambridge

Hamish Fulton

52 DOUGLAS SCOTT b. 1941 British
Panorama from the Summit of Everest Looking SSW, 1975
Barclay's Bank International/British Everest Expedition
C.25634
24·1 × 35·6 cm
C print
Given by the photographer

Professor Margaret Harker
Formerly Pro Rector of the Polytechnic of Central London; author of *The Linked Ring* (1979); chairman of the Print Collection Committee of the Royal Photographic Society. Specialist contributor on history, *The British Journal of Photography*.

54 EDWARD STEICHEN 1879–1973 American, b. Luxembourg
The Matriarch (for Federation of Jewish Philanthropies, New York) 1935
Circ. 971–1967
43·5 × 35 cm

56 EDWARD STEICHEN 1879–1973 American, b. Luxembourg
Evening Dresses for Vogue, 1930
Circ. 969–1967
35·5 × 28 cm

David Hockney
Painter, draughtsman, print-maker, set-designer, photographer. His exhibition and publication about art and its reproduction was held at the National Gallery as the last in the series *The Artist's Eye* in 1981.
David Hockney Photographs was published in 1982.

58 FREDERICK HOLLYER 1837–1933 British
Perseus and Medusa
From the *Perseus* series 1875–84
Ph. 2533–1898
30·3 × 27·5 cm
Photograph (platinotype) of a painting by E. Burne-Jones

61 DAVID HOCKNEY b. 1937 British
Scrabble Game, Bradford, 1st January 1983
Ph. 1–1983
Composite of C-type colour prints

Mark Holborn
Writer, co-editor of *Creative Camera* magazine. Author of *The Ocean in the Sand* (1978). Frequent contributor to periodicals in England and USA on the contemporary arts.

64 ROBERT FRANK b. 1924 Switzerland, American
Andrea, Pablo, Mary, Wellfleet, 1962
Ph. 354–1982
22·7 × 33·7 cm

66 EIKOH HOSOE b. 1933 Japanese
Portrait of Yukio Mishima from Ordeal by Roses, 1963
Ph. 1239–1980
18·4 × 27·3 cm

Sir Tom Hopkinson
Former editor of *Picture Post, Lilliput* and *Drum*; novelist, short story writer, autobiographer and broadcaster. Knighted for his services to journalism.

68 ROBERT DOISNEAU b. 1912 French
Le petit balcon, 1953
Ph. 254–1980
24·1 × 31·4 cm

70 LOUIS STETTNER b. 1924 American
Paris, 1949
Ph. 1449–1980
38 × 29·7 cm

Ian Jeffrey
Senior Lecturer in Art History, Goldsmiths' College, University of London. Author of *The Real Thing: An Anthology of British Photographs* (1975); *Cityscape* (1978); *Photography: A Concise History* (1982) and co-author of *Landscape in Britain 1850–1950* (1983)

72 ROBERT ADAMS b. 1937 American
East from Flagstaff Mountain, Boulder County, Colorado
Ph. 355–1982
17·8 × 21 cm

74 ROBERT WALKER b. 1945 American
Rockette backstage at Radio City Music Hall, New York, 1982
Ph. 357–1982
34·1 × 23·3 cm
Cibachrome

Chris Killip
Photographer. Author of *The Isle of Man* (1980); has directed a series of exhibitions at Side Gallery, Newcastle, including *Lewis Hine* (1977), *Robert Doisneau* (1982)

76 DANNY LYON b. 1942 American
Uptown Chicago, 1965
Ph. 359–1982
22·3 × 34 cm

78 ROBERT DOISNEAU b. 1912 French
La stricte intimité, 1945
Ph. 260–1980
28·3 × 24·7 cm

R. B. Kitaj
Painter, draughtsman, print-maker. Author of *The Human Clay* (exhibition catalogue, 1976).

80 E. J. BELLOCQ 1873–1949 American
Storyville Portrait c. 1913
Ph. 119–1979
20·3 × 25·5 cm
Printing-out-paper, gold-toned, printed from original negative by Lee Friedlander

82 ROBERT DOISNEAU b. 1912 French
Coco, 1952
Ph. 360–1982
32·5 × 24·5 cm

Valerie Lloyd
Photographic historian and consultant. Formerly Research Assistant, the National Portrait Gallery and Curator of the Royal Photographic Society. Author of many publications including *Photography: The First 80 years* (1976); *23 Photographers/23 Directions* (1978) and the guide to photographic processes in *Photodiscovery* by Bruce Bernard (1980)

84 WALKER EVANS 1903–1975 American
Bed, Tenant Farmhouse, Hale County, Alabama, 1936
Ph. 170–1977
18·8 × 23·5 cm

86 MAN RAY 1890–1976 American
Portrait of Lee Miller (modelling a bathing suit) *c.* 1932
Ph. 361–1982
29·6 × 19·7 cm

Donald McCullin
Photographer with *The Sunday Times.* Author of *The Destruction Business* (1971); *Homecoming,* (1978), *Hearts of Darkness* (1980). Warsaw Gold Medal, 1964; World Press Photographer Award, 1965 (among many other awards).

88 DMITRI BALTERMANS b. 1912 Russian
Looking for Loved Ones, Kerch, 1942
Ph. 362–1982
24·2 × 29 cm

90 SIR CECIL BEATON 1904–1980 British
Mrs Rhinelander-Stewart, 1933
Ph. 190–1977
25·3 × 19·7 cm

David Mellor
Lecturer in Art History at the University of Sussex. He has contributed to many exhibition catalogues including *The Real Thing: an Anthology of British Photographs 1840–1950* (1975). His exhibition and catalogue *Modern British Photography 1919–39* appeared in 1980. He introduced *Bill Brandt: A Retrospective Exhibition,* the Royal Photographic Society (1981).

92 PETER ROSE PULHAM 1910–1956 British
Leonor Fini, 1938
Circ. 3–1977
19·2 × 20·5 cm

94 DAVID BAILEY b. 1938 British
Jean Shrimpton, New York, 1962
Ph. 363–1982
50·8 × 40·6 cm
Given by David Bailey. Illustrated by courtesy of Condé-Nast Publications ©

Colin Osman
Editor and publisher of *Creative Camera*
magazine; a frequent writer on 19th-century
and modern photography. Author of
Munkacsi (1978) and *The British Worker –
Photographs of Working Life 1839–1939*
(1981)

96 MARKÉTA LUSKAČOVÁ b. 1944
Czechoslovakia, British
Sleeping Pilgrim, 1967–70
Ph. 1680–1980
22·2 × 32·1 cm

98 ANDRÉ KERTÉSZ b. 1894 Hungary,
American
Satiric Dancer, 1926
Ph. 210–1976
24·7 × 19·5 cm

Tom Picton
Photographer with *Time* magazine. Former
member of Half Moon Photography Work-
shop. Former Lecturer in photography at the
Royal College of Art.

100 MAX YAVNO b. 1911 American
Muscle Beach, 1949
Ph. 381–1982
20·2 × 34·3 cm

102 ROGER MAYNE b. 1929 British
A Page from the Southam Street Album,
1956–61
Ph. 277–1978
36 × 54 cm
Given by the photographer

Professor Lord Quinton
Professor of Philosophy and President of
Trinity College, University of Oxford.
Chairman of the Arts Council of Great Britain
working party on photography, 1981–82

104 ANSEL ADAMS b. 1902 American
*Mount Williamson, Sierra Nevada, from
Manzanar, California,* 1944
Circ. 595–1975
55·8 × 71 cm

106 DIANE ARBUS 1923–1971 American
*Retired Man and his Wife at Home in a Nudist
Camp One Morning in New Jersey,* 1963
Circ. 308–1974
36·5 × 38 cm

Professor Aaron Scharf
Formerly Professor of Fine Art, The Open
University. Author of *Art and Photography*
(1974), and *Creative Photography* (1965),
many learned articles and *Modern Art 1848
to the Present (1975–6)*

108 ANONYMOUS PHOTOGRAPHER
for Topical Press
Olympic Games Sensation, 1908
11–1965
24·5 × 28·7 cm
From an album produced and presented by
Ilford Ltd

110 EUGÈNE ATGET 1857–1927 French
Church of St Gervais, Paris, c. 1900
224–1903
21·1 × 16·7 cm
Albumen print

Chris Steele-Perkins
Photographer with Magnum. Author of *The
Teds* (1979) and *About 70 Photographs* (1980).
His photographs from Beirut will appear in
book form in 1983.

112 DONALD McCULLIN b. 1935 British
*Twenty-four year-old Mother with Child
Suckling Empty Breast, Biafra,* 1969
Ph. 1315–1980
38·8 × 25·6 cm
Given by the photographer

114 JOSEF KOUDELKA b. 1938 Czech
Straznice, 1965
Circ. 522–1976
23·2 × 35·3 cm

Caroline Tisdall
Writer, photographer and film-maker.
Author of *Italian Futurism* (1977); *Coyote*
(illustrated by her own photographs) (1976);
Joseph Beuys (1979); *Picturing the System*
(1981); *Beirut: Front Line Story* (1983)

116 CHRIS STEELE-PERKINS b. 1947 British
*Shattered Portrait of Dead Palestinian in
Cemetery near Beirut*, 1982
Ph. 365–1982
33·9 × 22·7 cm

118 JOHN DAVIES b. 1949 British
Scafell Pike, towards Great Gable, Cumbria
Ph. 364–1982
26 × 34·5 cm

Peter Turner
Writer, photographer, lecturer. Formerly
co-editor of *Creative Camera* magazine and
publisher of Travelling Light books. Author
of *P H Emerson* (1974)

120 WALKER EVANS 1903–75 American
Penny Picture Display, Savanna, 1936
Ph. 182–1977
24 × 20 cm

122 LEE FRIEDLANDER b. 1934 American
Tampa, Florida, 1970
Ph. 774–1980
19 × 28·3 cm
Given by the Gordon Fraser Charitable Trust

Marina Vaizey
Writer, *Sunday Times* art critic, author of *The
Artist as Photographer* (1982)

124 DOROTHEA LANGE 1895–1965 American
White Angel Breadline, 1933
Ph. 371–1982
12·4 × 10·1 cm
Exchange with the Oakland Museum,
California

126 ALFRED STIEGLITZ 1864–1946 American
Equivalents, 1927
Ph. 366–1982. and Ph. 367–1982
11·8 × 9·2 cm

Dr Mike Weaver
Reader in American Literature, University of
Oxford. Author of *William Carlos Williams*
and numerous essays including *Alvin
Langdon Coburn: Man of Mark*, Royal
Photographic Society, 1982. Past Chairman,
Photography Committee, Arts Council of
Great Britain.

128 PAUL STRAND 1890–1976 American
Blind Woman, New York, 1916 from
Portfolio III
Ph. 372–1982
33 × 25·3 cm
Modern print (1975)
Given anonymously in memory of Gordon
Fraser. © The Paul Strand Estate 1971

130 PAUL STRAND 1890–1976 American
Young Man, Gondeville, Charente, France,
1951 from Portfolio III
Ph. 373–1982
27·8 × 22·2 cm
Modern print (1975)
Given anonymously in memory of Gordon
Fraser. © The Paul Strand Estate 1971

NOTE: All photographs are gelatin-silver prints and purchases unless otherwise stated.

Introduction

This exhibition and book inaugurate the galleries of photography at the V&A, together with a twin display and publication, *The Art of Photography: a guide to early photographic processes, 1840–1914*. The Museum's concern is to present the history of photography as an expressive medium. Collecting began with the Museum itself in 1856, when photographs were acquired from the annual exhibition of the Photographic Society of London (later the Royal Photographic Society). Among the photographs bought in that year were examples by Frederick Scott Archer. It is both interesting and moving that the Museum should have acquired before his death (in the following year) photographs by the sculptor and inventor who gave the world – quite literally, he applied for no patent – the collodion process which revolutionized photography. In 1858 the Museum was host to the Society's exhibition – at which, for example, Robert Howlett's famous documentary photographs of the construction of Brunel's *Great Eastern* were shown. In the 1860s Julia Margaret Cameron used the Museum's darkrooms and presented many of her photographs to the collection. It seems doubtful that there is any other Museum in the world in which a photograph by Mrs Cameron can be labelled 'Given by the Photographer'.

The Museum has a long and interesting history of collecting photographs.* The years since 1977, when the collection was transferred from the Library to the Department of Prints and Drawings, must have seen the most intense period of collecting photographs since the 1860s. The reason for this is that the Minister for the Arts in 1975 laid down a division of responsibilities in the field of photography among the national museums. The V&A was charged with the policy of building on its existing holdings as the national collection of the art of photography (while the scientific story continued with our colleagues in Exhibition Road at the Science Museum, and the National Portrait Gallery furthered its precise collecting brief – photographic portraits of notable Britons past and present). Since the mid-1970s, then, the Museum has been actively collecting to provide a systematic representation of the art of photography, internationally and from the beginnings of the medium to the achievements of today.

Some unique items essential to the study and appreciation of British photography in the early period have appeared on the market in recent years and funds have been made available for their acquisition. Such purchases – and some very significant gifts – will form part of the Museum's forthcoming exhibition of British photography in the 19th century (1984). However, the Museum's main objective in photography over the last eight years has been to form a major representation of twentieth-century photographs, with a strong focus on contemporary activity.

The opening of the galleries provides the opportunity to review the Museum's twentieth-century holdings to date. It is already a very large collection. We decided that it would be appropriate and interesting to invite a number of distinguished individuals, who have had much to say about the art of photography in recent years, to animate this venture by choosing two works each from the collection and writing about them in a personal and informal way. Photographic history is, of course, an enormous subject and we have often turned to colleagues for specialist advice – and been the beneficiary of yet others for their exhibitions, publications and polemics. Much of the best specialist information is to be found in the minds of the practitioners themselves. The Museum is, obviously, the recipient of an enormous quantity of information of all kinds which, literally, informs the growth of the collection. A particularly good example is to be found in the statement by Colin Osman about the

*The Museum's register of photographic acquisitions 1856–1914 has been published by World Microfilms together with a colour microfilm of approximately 10,000 photographs from the Museum's collection 1840–1914.

marvellous photograph of a sleeping pilgrim – which he was the first to publish in the West. This led to its acquisition by the Museum and its presentation here to a still larger audience.

The germ of the exhibition may have another origin, however, than that of acknowledging the presence of a many-sided, creative environment in which the Museum participates. A few years ago I went to Laugharne to see the original of Dylan Thomas's Milk Wood. The famous boathouse in which he wrote *Under Milk Wood* was locked but had a large key-hole. I could see a stagey clutter of manuscripts on his writing table, books, empty quarts of Guinness, some photos of young poets of the Thirties. Then something I hadn't expected – a photograph torn out of a newspaper and tacked to the wall. It was a picture Cartier-Bresson took in Spain in 1933 of a woman carrying a shopping bag with, apparently, a baby in it. It is, nowadays, well-known. Seeing it from the unexpected viewpoint of Dylan Thomas stripped the picture of its familiarity for a moment. The Surrealist elements in the poet flashed briefly in the image by the (Surrealist) photographer, like a car's headlights passing across a mirror.

Not long afterwards the Museum's archive of 390 Cartier-Bresson photographs was shown at the Hayward Gallery. The Rt Hon Denis Healey, then Chancellor, had the somewhat unenviable – at least very difficult – task of defining the master's work in about five minutes of a *Newsnight* programme. He surprised and delighted me by referring in particular to the *Picnic on the Banks of the Marne* of 1938. 'It's all in the moment of the pouring of the wine,' he said (I quote from memory), pointing to the fulcrum of the composition, 'that is the key to the picture.' He then quoted these lines from William Blake – 'He who kisses the Joy as it flies / Lives in Eternity's sunrise'. This is one of the grand illusions of photography. Of course, the picture commands our interest from many other angles which it would take a book to encompass. However, it was very well said and we are sorry that Mr Healey was not able, for understandable reasons, to accept our invitation to contribute to this exhibition. We thank all our selectors for the time and thought they generously gave to the task. The intersections between individuals and their chosen photographs in these pages illuminate not only the V&A's twentieth-century collection but – vividly – many of the most engrossing and disturbing perceptions of photography.

There is a little space for me to mention three individuals who have helped to build up the twentieth-century collection. The first is Carol Hogben, Deputy Keeper of the National Art Library at the V&A. In the 1960s and early '70s Carol Hogben acquired for the Museum photographs by Ida Kar, Edward Steichen (two are illustrated here), Bill Brandt, Cecil Beaton, Man Ray, Herbert Bayer, Jacques-Henri Lartigue, Atget (in the Berenice Abbott rendition), Don McCullin, Roger Mayne, Valerie Wilmer, Raymond Moore, Josef Koudelka, Nick Hedges, Paul Caponigro and others. He was also the first to acquire and exhibit the photographs of David Hockney. Undoubtedly his most important exhibition in the photographic field was the Cartier-Bresson show of spring 1968 (it afterwards toured throughout the country). At the National Portrait Gallery Dr Strong, as he then was, simultaneously presented the first major exhibition of Cecil Beaton. This pair of exhibitions, and the critical activity they provoked, very much altered the atmosphere in which photography was regarded. These close-up views of the *oeuvres* of a great humanist and a brilliant stylist changed the mental set. I have always remembered, fairly precisely, some passages from Carol Hogben's catalogue. He wrote, for example:

In many ways the achievement of an outstanding reportage photographer such as Cartier-Bresson is far closer to that of a visually biased writer than to that of any 'fine' graphic artist. It is precisely one of the things that distinguishes a practitioner of his rank that from looking at a body of his work one is able, without any difficulty at all, to apprehend the broad qualities of his mind – in this case, his compassion, his hatred of pretence, his sense of irony, his care of innocence. It is a mind far nearer to Turgenev, shall we say, than to a Toulouse-Lautrec.

Again, writing of the spectrum of options in which we might best place our sense of photography as an art medium, he suggests this:

…it may be more helpful to be thinking of photography as closer to writing than to graphic art. For the materials that a writer uses are common to everyone. Everyone of us

strings sentences together from morning to night, but nobody gets in a trauma as to how one can possibly tell who is a fine writer and who is none. Indeed, in all those newspapers and magazines that get thrown away, no little fine writing, by undoubted artists, gets trashed in just exactly the same way as do the photographs.

I am sure the whole essay will be reprinted one day.

The second person who has a special bearing on the collection is Bill Brandt. His exhibition in 1970 (the first by the Arts Council of Great Britain at the Hayward Gallery devoted to a living photographer) completed the work begun by the exhibitions already referred to. Sixty-five photographs were shown and the exhibition drew together several notable talents. It was selected by John Szarkowski, Director of the Department of Photography at the Museum of Modern Art, New York (organizer of the show), introduced by Aaron Scharf and designed by Herbert Spencer. It toured throughout the country and persuaded many people previously indifferent to the medium that photography could, after all, possess an unlooked-for eloquence. In 1975 Bill Brandt selected for the Museum *The Land: 20th century landscape photographs* (shown also in Edinburgh, Cardiff, Belfast and Venice). About 180 photographs from the exhibition became part of the collection (two were selected by Hamish Fulton for this book). Brandt's talk about photography, utterly serious and utterly simple has – partly because of its absence of aesthetic flim-flam – become as addictive as the presence of concentrated visual intent in his photography. BBC-TV placed both qualities before a large audience for the first time in January 1983 by showing an outstanding film about Brandt by Peter Adam.

The late Gordon Fraser helped the collection in very tangible ways but he was the most timely as well as unpompous of benefactors. The Museum turned to Gordon Fraser at times when other major purchase commitments had left bills critically unpaid. This sometimes happened in the 1970s when an item of the greatest national importance was released onto the market without warning and all funds were frozen. Gordon Fraser insisted that the Museum convince not only himself but the fellow-trustees of the Gordon Fraser Charitable Trust of the worth of the photographs in question. His gifts all occurred at especially necessary times. He helped out without fuss – no cheques changed hands in front of cameras – and eventually decided he ought to give something to other favourite museums such as the Tate and the Fitzwilliam in Cambridge. He was, of course, very well-known as a general provider of greetings cards, wrapping papers and postcards. As a young man at Cambridge University in the thirties, he published pamphlets by D.H. Lawrence and F.R. Leavis and ran a bookshop in which he tried unsuccessfully to sell etchings and lithographs by Grosz, Picasso and Matisse (they remained his all his life). In an obituary his friend Basil Davidson suggested that Gordon Fraser's aim as a publisher – of the books of Bill Brandt as well as all the cards and papers – was part of a tradition of concern for the currency of everyday things. Small things could and should be *considered* and of value. Long ago, about 1960, he initiated a series of postcards of architecture. He commissioned first-class photographers – Helmut Gernsheim, Eric de Maré, Raymond Moore and Edwin Smith among them – but the series did not take. Perhaps it would now. Gordon Fraser died in a car crash at the age of seventy. His gifts provided the nucleus of the Museum's collections of Paul Strand, Edward Weston and Lee Friedlander. His name is remembered in three photographs chosen for this book.

There are some small anomalies in the selection. Harold Evans chose only one photograph because he was away in the U.S. It is a Lartigue he assumed we would have: we thank Olympus Gallery warmly for adding it to the collection as a gift. In addition to her first choice, Marina Vaizey chose two *Equivalents* by Alfred Stieglitz in order to suggest their serial character (these belong to a set of five). David Hockney is alone in selecting a pre-1900 photograph and a work of his own. His remarks make the reasons for his choice admirably clear.

Finally, we very warmly thank Ilford Ltd for supporting the production of this book and the exhibition.

Mark Haworth-Booth
Assistant Keeper of Photographs

Roy Strong

SIR CECIL BEATON
1904–1980 British
Queen Elizabeth II at her Coronation, 1953
3475–1953
20·4 × 15·2 cm

This portrait provides a memorable link with the accession year – a modern *annus mirabilis* – and with the visit of Her Majesty to the Museum on the occasion of the opening of the Henry Cole Wing in March 1983. The Museum's last major expansion in South Kensington began in 1899. Queen Victoria herself laid the foundation stone of the building on Cromwell Road designed by Sir Aston Webb. The occasion, in the 62nd year of her reign, was Queen Victoria's last public state ceremony. These are the words with which she concluded her address:

I gladly direct that in future this Institution shall be styled 'the Victoria and Albert Museum', and I trust that it will remain for ages a Monument of discerning Liberality and a Source of Refinement and Progress.

Cecil Beaton describes in his diaries the nightmare marathon of taking photographs for the Coronation in 1953. Beaton believed that he owed the commission to the Queen Mother, faced as he was by competition from Prince Philip's friend, Baron. He recounts the creation, days in advance, of his sets in the Green Drawing Room at Buckingham Palace: 'Now all hands must work desperately hard to get electric cables running with juice and backgrounds and curtains and various "blow-ups" in place.' What we see in this portrait is one of these blow-ups, that of Henry VIII's Chapel in Westminster Abbey.

This is one portrait from a massive photographic session involving family groups as well as separate studies of members of the Royal Family, taken immediately on their arrival back at the Palace from the Abbey. The diary entry captures the frenzy that attended the work as well as the shortness of the time. However, neither of these circumstances could ever be guessed from the resulting portrait, whose immediate effect is that of the stillness and timelessness of another world. 'I asked her to stand against my blow-up Abbey background,' he writes. 'The lighting was not at all as I would have wished but no time for readjustments: every second of importance.' His sister, Baba, arranged the Queen's train.

What we see is a brilliantly composed royal image in which the Queen is seated in a manner that recalls Britannia on the coinage. Her face is in regal profile, an aureole of light arranged from behind to betoken the dawn of a new era. Beaton's strong sense of style and of the historic past are caught in this highly artificial picture. Here a monarch of the twentieth century has been arranged into a formal composition redolent of royal portraiture of the baroque age superimposed onto the receding banners and tracery of the remote gothic centuries. So successful is the result that Beaton has made us accept his architectural fiction as fact.

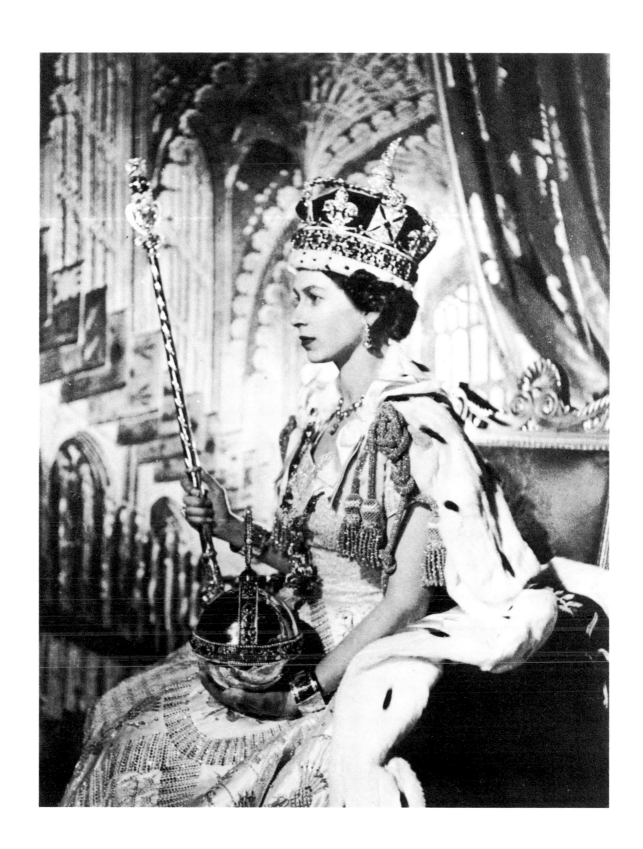

David Bailey

JOEL-PETER WITKIN
b.1939 American
Woman Breast-feeding an Eel, 1980
Ph. 352–1982
36·5 × 36 cm
Partial gift of David Bailey

If you ask people to choose two movies, one is always going to be, in all likelihood, *Citizen Kane.* Wonderful, but I've seen it ten times, let's give it a rest. The same applies to photographs. I don't want to see another exhibition of Cartier-Bresson's *Picnic on the Banks of the Marne,* or Lartigue's *Jumping Lady,* or *Moonrise over some Mexican Village,* no matter how significant these pictures may be. I want to see the new. Having stated the above, for me, the two most important images of this century are Paul Strand's *Blind Woman* and Walker Evans's *Studio.* They are imprinted on our collective consciousness to such a point that to mention them is to see them, so I see no need to choose them for this exhibition.

The pictures of my choice are both gambles, because time is the best judge of our efforts. I am certain of Fox Talbot and Fenton, but obviously Les Krims and Duane Michals need to ferment a bit longer. I have chosen Witkin and Bernard Faucon images, because they are showing me the new.

Witkin's picture of the girl breast-feeding an eel is very similar in subject content to the painting by Giampietrino (Gian Pietro Rizzi) of Cleopatra holding a serpent to her breast in the act of suicide. I don't know if Witkin is familiar with this painting, which is in the Louvre Museum: it would seem too much of a coincidence if he were not. In my opinion, Giampietrino's painting does not work. Cleopatra, who is experiencing what must be quite a painful and unusual occurrence, is looking away from the snake with an indifferent expression, as though she has just been distracted by a kettle boiling over. Witkin's image is altogether a different story. This is some strange marriage between Bosch, Max Ernst, Bacon and Witkin. The breast-feeding lady has no face. Maybe her lot is to remain in Hell, just feeding a multitude of sexual wriggling eels. She has a Victorian presence about her which gives one a false sense of comfort in this unfriendly image.

Faucon's *Banquet* at first glance is the Last Supper, but there are only twelve plastic children, so that rules that out. Is it innocence eating, drinking, playing music, while Rome burns on our doorstep? Like Witkin's Victorian lady, Faucon gives us the same sense of security, by introducing so much nostalgia into his photograph. They start at opposite poles, Witkin bizarre and Faucon ordinary; both leave you visually paranoid.

Every day I want to read something new, an opinion, a point of view. My greatest pleasure in life is to see a new image, or one I never thought of. I don't care if it is wrong, time will decide that. Whenever I look through a camera, I hope to see the new. If it happens six times a year, I'm ahead.

Laurens Van Der Post, in his book on Jung, quotes:

It would seem as if always in one's deepest potential there is axiomatic conviction that life was created as a means of answering a universal question, and that when the question is ultimately answered, life will be put, as it were, out of business and something else will come to take its place.

This something in its place will be the 'new'. In the new I'm looking for things forgotten. For we know everything; it's up to the poet to jog our memories, to help us remember.

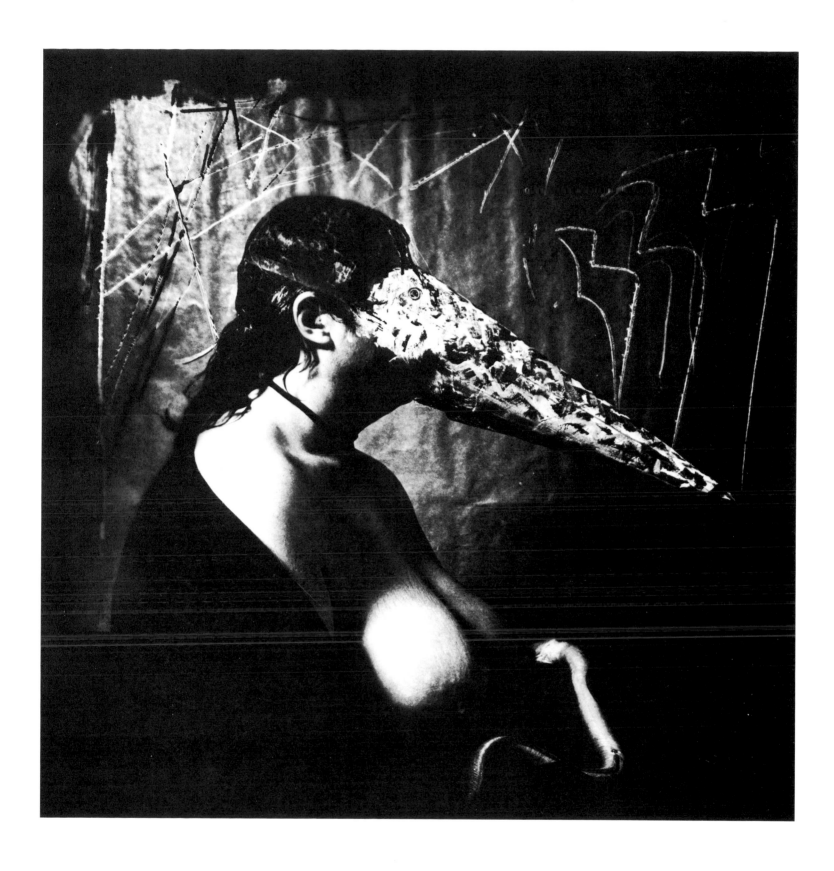

David Bailey

BERNARD FAUCON
b.1950 French
Le banquet No 27, 1980
Ph. 353–1982
31 × 30·8 cm
Fresson print

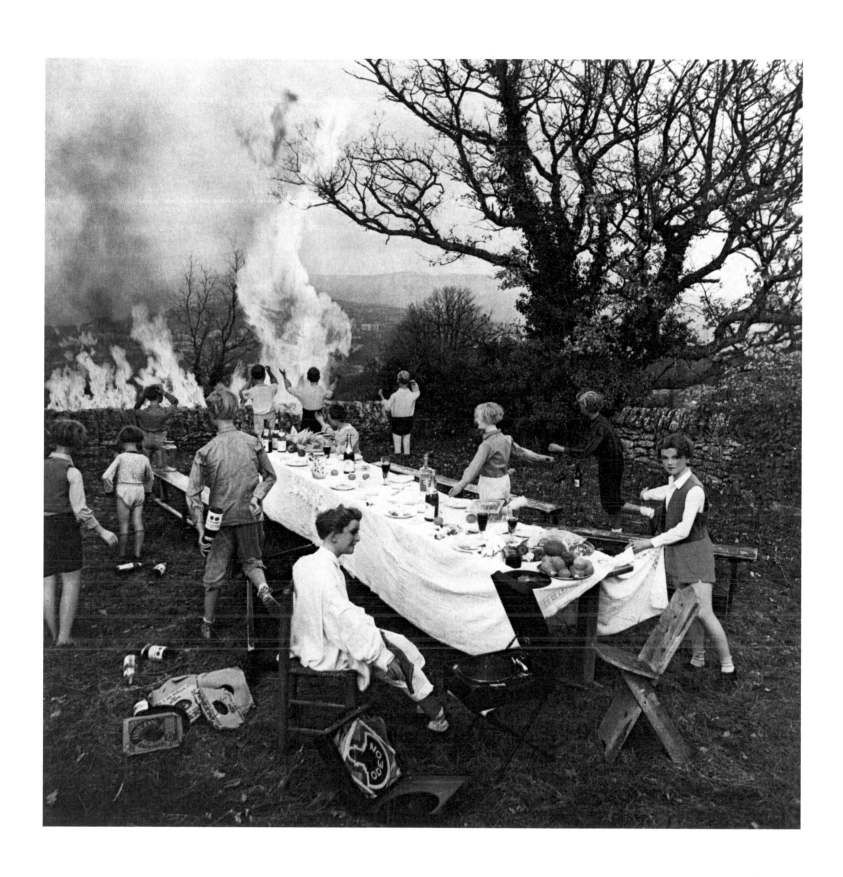

Bruce Bernard

IRVING PENN
b.1917 American
Nubile Young Beauty of Diamaré, 1969
Ph. 400–1981
48·6 × 48·6 cm
Platinum and palladium
Illustrated by courtesy of Condé Nast Publications ©

Irving Penn makes one feel that he has more 'class' than any other photographer of the century, or indeed ever. One might well consider quite a few others greater than he, but Penn's fastidious selection of subject, marvellous simplicity of pictorial design, and immaculate print quality make his whole opus gently gleam like a very expensive, perhaps platinum, artefact. In his pictures of people he provokes an exact identity of interest in his subject and what he has done with it that outdoes even Nadar. It gives his work a strangely lapidary quality as if he had fashioned very precise niches in space for his models. It is very impressive but also very cool. In *Nubile Young Beauty of Diamaré* he found a model who could almost imperceptibly crack the mould and raise the temperature and thus helped him make what is now the Irving Penn I admire most.

He described the assignment for *Vogue* on which he took the picture in an introduction to a book of photographs of the various primitive peoples involved in it. He found that using a portable studio with a north light was the only way that suited both him and his subjects and that they responded very positively to it. In the studio he and they were both, he says, as in a limbo, cut off from their own familiar lives and alien to each other. Nevertheless the subjects seriously addressed themselves to the camera and allowed Penn to arrange them by touch 'in relationships that seemed true to them'.

The girl was probably one of the twenty-five wives of a chieftain of the Kindi, and Penn writes of the whole tribe's 'perfect physical beauty and peace of spirit'.

One of the greatest pleasures of photography is, I think, its ability (in the right hands) to record radiant individuals who make one forget for a few moments one's doubts about the human race; and it does so in a way no other art quite can. Penn, by taking his intensely sophisticated eye and technique to a culture as unlike New York as any could be, did something actually unprecedented in photography, and, with a girl who exactly understood her own image and how to give it to him, made what I think is one of the most beautiful photographs ever taken.

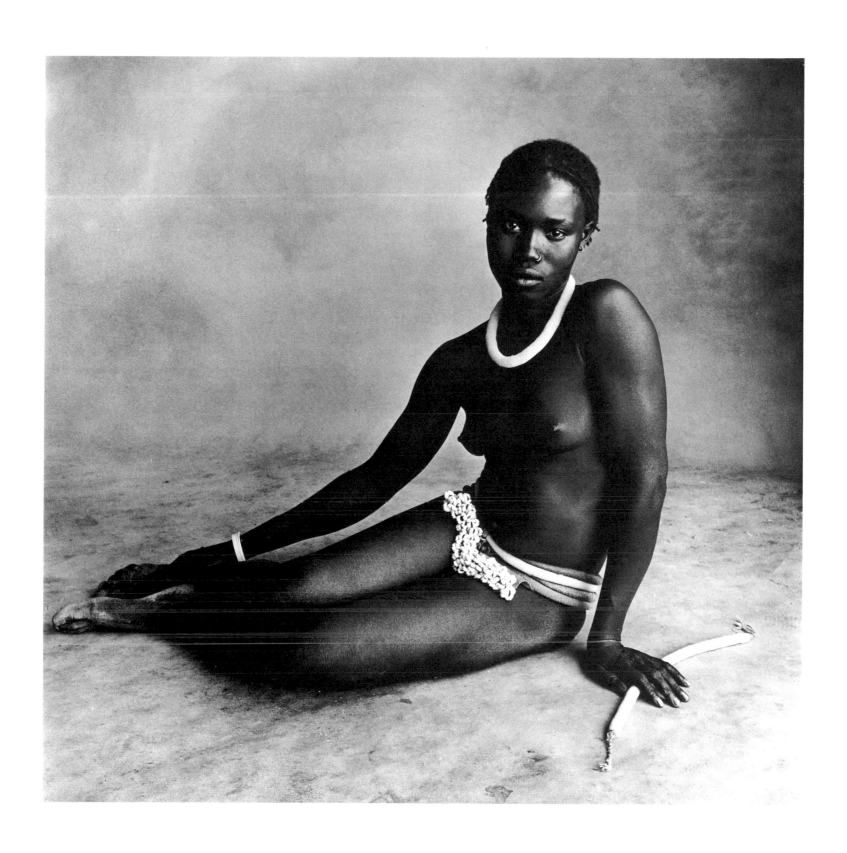

Bruce Bernard

DON McCULLIN
b.1935 British
Group of Young Men in Italian Café, Finsbury Park, 1958
Ph. 1244–1980
25·3 × 24·7 cm
Given by the photographer

Don McCullin has been, for a long time in my opinion, one of the best British photographers of the century and I'm certain that he's its greatest war photographer. He has demonstrated a talent that quite uniquely combines brilliant reportage and picture making, and his intense but complicated feelings about his generally tragic or depressing subject matter involve those who look at his pictures closely in a painful but ultimately enriching encounter. I could have chosen from the V&A collection his masterpiece of the discovery of the corpses in Cyprus in 1964, but I thought it would be better to show, in the isolation it deserves, a little-known photograph that I believe unmistakably proclaimed his talent very early in his photographic life.

He took it with a second-hand Rolleicord in a 'caff' in Finsbury Park in 1958 and it is of some fairly hard nuts he had been to school with. He used a flash unit which he was very excited to possess, placing it some way to the right of the camera, which was hand held and not on a table. He arranged his friends in the square view finder, instinctively exploiting a foreground of bentwood chair tops which are an important part of a very spare and not at all unsophisticated composition.

The picture communicates its bleak little anecdote and the role of the cigarette and hat in those days with a pictorial talent that two years later was to begin broadening its horizons and technique very rapidly. He says the police stopped him just after he'd taken it saying that they had heard that 'a stolen camera was being used in the neighbourhood'. They had to let him go, though, and for two years he took his own photographs only fitfully (but not from fear of the police) and for a living he made photocopies of drawings for animated films. Then in 1960 he started on his remarkable and dangerous career, leaving behind him this precise slice of his life for us to consider now; in my case with interest and admiration.

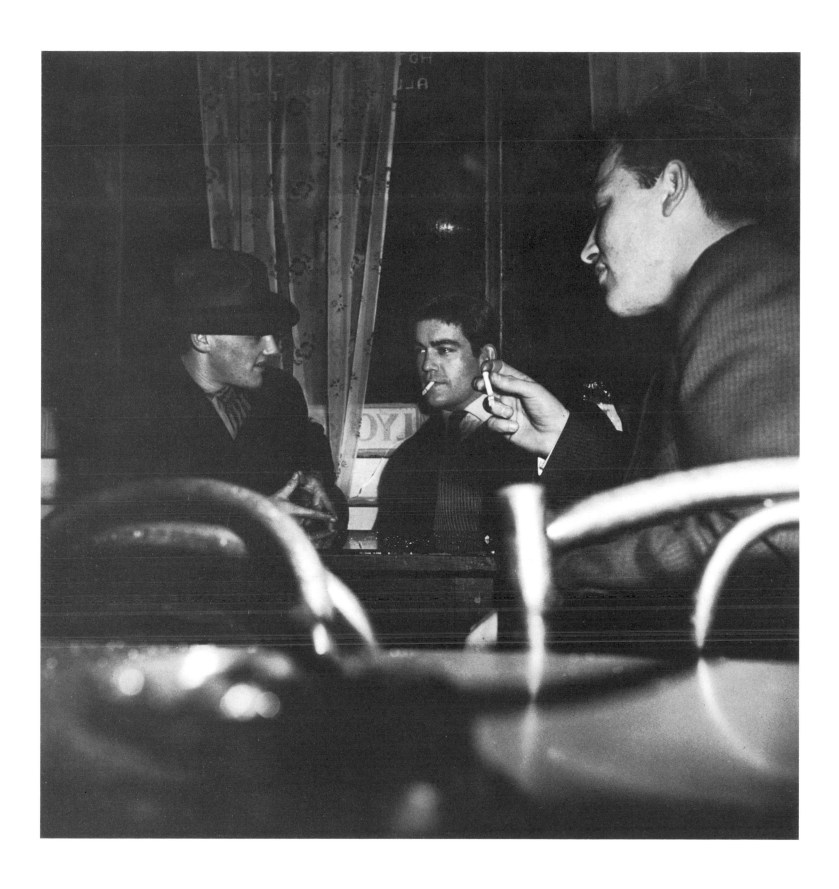

Dorothy Bohm

ROBERT FRANK
b.1924 Switzerland
London Street, 1951
Ph. 1229–1980
24·8 × 42·8 cm

One of the images I have chosen is *London Street* (1951) by Robert Frank. I first saw this photograph in the January 1962 issue of the prestigious Swiss art magazine *DU*. Robert Frank was born in Switzerland and moved to America in 1947. The magazine devoted many of its pages to Robert Frank and his work. One section showed his photographs of London. Although I looked with the greatest interest at all of the pictures I found the photograph of the London Street in 1951 particularly moving. It shows a hearse waiting with its door wide open standing in a misty, bleak street of identical terraced houses and rows of chimneys pointing towards the grey, empty sky. I knew London in the early fifties. The architecture of such a street and the melancholy atmosphere were familiar to me, but there was much more than my own emotional response to this image to make it memorable. I studied the photograph more closely each time I saw it again. I was intrigued and interested to find out what happened in that street when Robert Frank saw it in 1951 and when he decided to hold that moment in time for us to see.

There is tension in the way the photographer shows us the massive shape of the black hearse in the foreground and at the same time the empty space inside the hearse with the open door makes us anxious. The camera has been placed so that we are led into the misty perspective of the street. We find sadness and mystery but there is a welcome counterbalance to this mood provided by the youngster running with great vitality along the street away from the hearse. The child appears to be running joyfully and brings young life and hope into the picture. The positioning of the child's figure and its shadow upon the wet pavement make the picture work. Another sign of life is glimpsed through the glass pane of the open door of the hearse. One discerns a street-cleaner with his dustcart and a lorry can be seen in the distance. Life carries on.

Recently I found the 1962 Swiss magazine among my books and wondered if I could find something in it of relevance to my own assessment. I think it is of interest to-day to read what Robert Frank himself said of his photography in 1962. I quote in translation from the German:

Black and white are the colours of photography. To me they signify the alternative of hope and despair to which mankind is forever exposed. Almost all my photographs show people. They are seen simply, as though with the eye of the man in the street. I feel that it is essential for a photograph to show the human aspect of the moment.

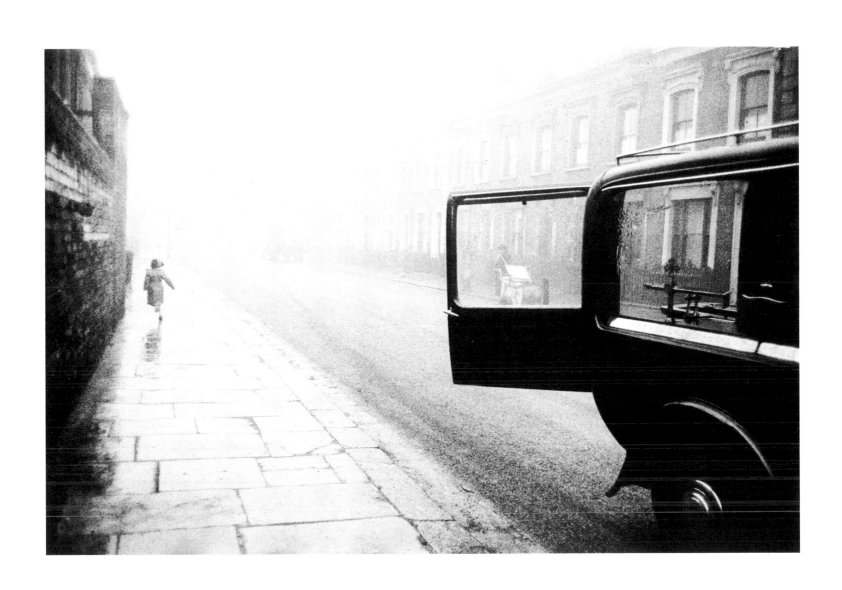

Dorothy Bohm

WILLIAM KLEIN
b.1928 American
Spanish Harlem, c. 1954–1955
Ph. 123–1979
22·9 × 30·1 cm

The boy's gaze imposes itself upon the viewer and makes one look again at the photograph William Klein took of the black youngster in New York in 1954. Why does this picture have the power to arrest attention? There is little drama in the child sitting there peacefully and the image does not command pity or other strong emotion. However, a strong sense of movement and energy radiates from the busy background against which the boy is sitting. The child and what we are shown of the adult figure next to him seem to fit snugly into the background of flashy, lit-up consumer advertisements. To me the figures appear to say: we are here and we belong here.

William Klein is both photographer and film-maker. His still photographs have the film-maker's vision imprinted on them. The photograph I have selected is included in the famous, now out-of-print book entitled *New York*. This book was published by *Photography* magazine, then at Old Bailey, London, in 1965, when it was edited by Norman Hall for about ten years from the mid-fifties; he then became the picture editor of *The Times* and died shortly after his retirement from the paper a few years ago. Klein told me himself that it was due to Norman Hall that *New York* was published. Norman's deep understanding of good photography and his remarkable ability to promote imaginative and original work played an important role; many of the world's great photographers have acknowledged their debt to him.

The maquette of the book was designed by William Klein himself and its full title reads:

LIFE IS GOOD & GOOD
FOR YOU IN NEW YORK
William Klein Trance Witness Revels

Thus the title of the book promises unusual photography and the book indeed lives up to this promise. We are given shock treatment, allusion, satire and humour coupled with acutest observation. In the mid-fifties I was a college-trained professional photographer of Klein's generation. Klein, a self-taught photographer as well as film-maker, painter and writer, made me re-examine what I had hitherto considered to be good photography. He breaks every rule and convention in order to get across his veracity of vision; he uses blur, grain, high contrast, foreshortened perspective and unusual cropping. Here is Norman Hall's own comment on Klein, published in *Photography Year Book 1961*:

When, after some years in Europe, William Klein went back to his home town, New York, he chose a miniature camera to say what he thought about it. Nothing like Klein had ever happened before in the world of photography. His vision was disturbing and what he saw he recorded in a way which was intense, acid and dramatically true. When his book, *New York*, appeared photographers everywhere began to take notice. Opinions differed strongly but on one thing they all agreed: Klein could not be ignored.

William Klein groups his pictures in the *New York* book in eleven sections and gives these laconic titles such as 'Décor', 'Parade', 'Gun', 'Extase', etc. The picture of the boy I have chosen is the first in the section entitled 'Dream'. Here Klein has allowed the magic of the moment to work. To get the full impact of the image, the original print shown in the present exhibition has to be seen rather than the reproduction in the book. Although a black and white photograph, Klein printed it in a warm tone with a particularly beautiful tonal range which endows this image with vibrating life.

Looking at pictures by great photographers we learn not only about their subject matter but sense also their own hopes and despairs. The photograph not only communicates but invites questions.

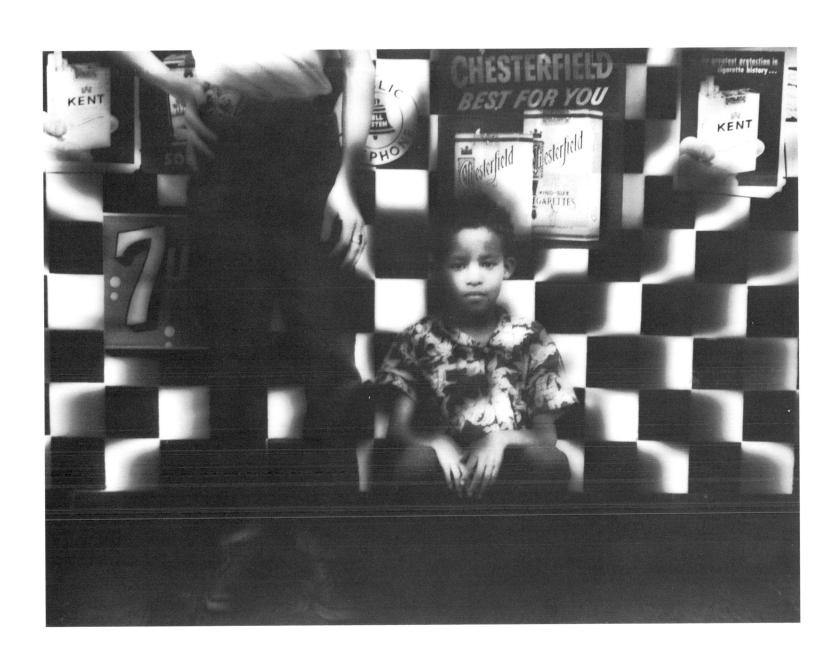

Mark Boxer

EUGÈNE ATGET
1857–1927 French
Intérieur de Monsieur T., négociant, rue Montaigne, 1910
Ph. 1157–1980
23·9 × 17·9 cm
Modern albumen print made from Atget's original negative by
Chicago Albumen Works, published by
The Museum of Modern Art, New York, 1980

The photographers I particularly admire are those who, apart from a mastery of their craft, subjugate themselves to their subject matter. In the last analysis they are content simply to record. This is true of many anonymous photographers as well as Hill and Adamson, Fenton, Primoli, Lartigue, Walker Evans, Adams, Sander, Cartier-Bresson and Don McCullin to name but a few favourites.

In the V&A archive you need go no further than the 'A's to find a true master of this idiom. Atget was both a sailor and an actor before he became a photographer. He specialised in the photographing of buildings in Paris largely for the use of painters. The handmade sign on his door said 'Documents pour Artistes'. In the process he also became a great street photographer, known now for his photographs of shop windows, Paris workers and prostitutes. His work appeals to me for reasons I find difficult to analyse. Is it the admixture of both humility and grandeur in his work and that his pictures can be disturbing and at the same time serene?

These two prints are lovingly reprinted on albumen paper from original negatives which have come down to the Museum of Modern Art from the collection of Atget's admirer and biographer Berenice Abbott. Both photographs are haunted by ghosts. The two pillows in the apartment of Monsieur T. in the Rue Montaigne seem to conspire together to whisper of liaisons enjoyed in the past. Unlike today's photography, the long exposure seems to allow more of the spirit of Atget's subjects to seep through the lens and eventually inhabit the very paper of the print.

The second photograph is of a landscape near Ville d'Avray favoured by the painter Corot. There is also a later photograph of the same boat taken in old age with a branch of a tree like a giant elbow weighing the boat down, its peeling hull now covered with the falling leaves of winter.

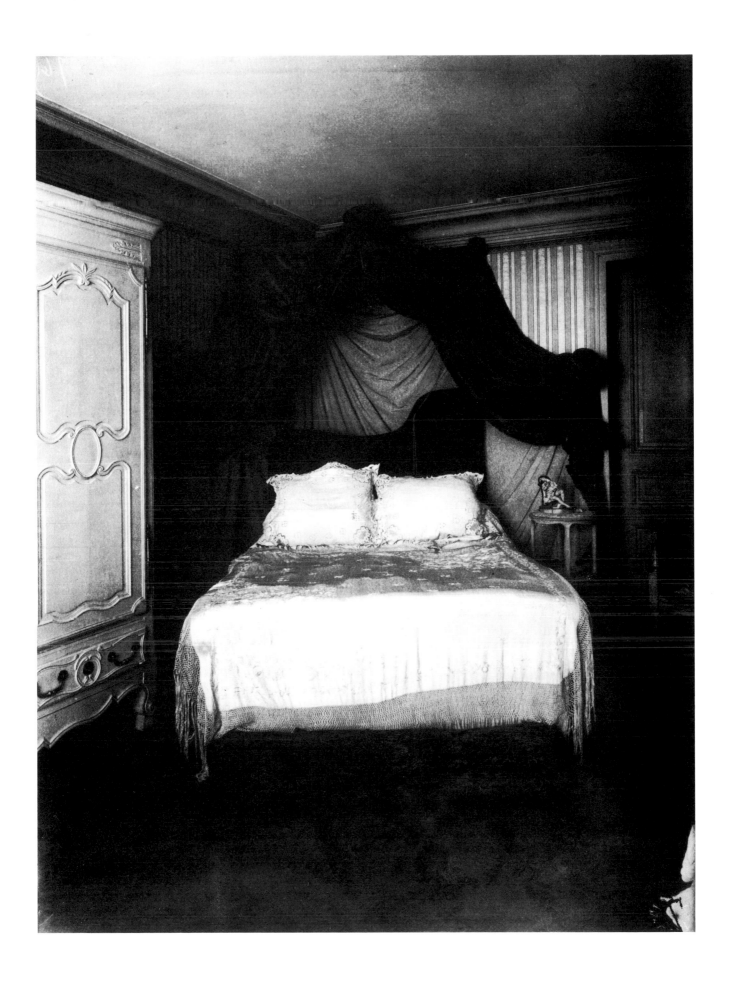

Mark Boxer

EUGENE ATGET
1857–1927 French
Etang de Corot, Ville d'Avray, before 1910
Ph. 1163–1980
17·9 × 23·8 cm
Modern albumen print made from Atget's original negative by
Chicago Albumen Works, published by
The Museum of Modern Art, New York, 1980

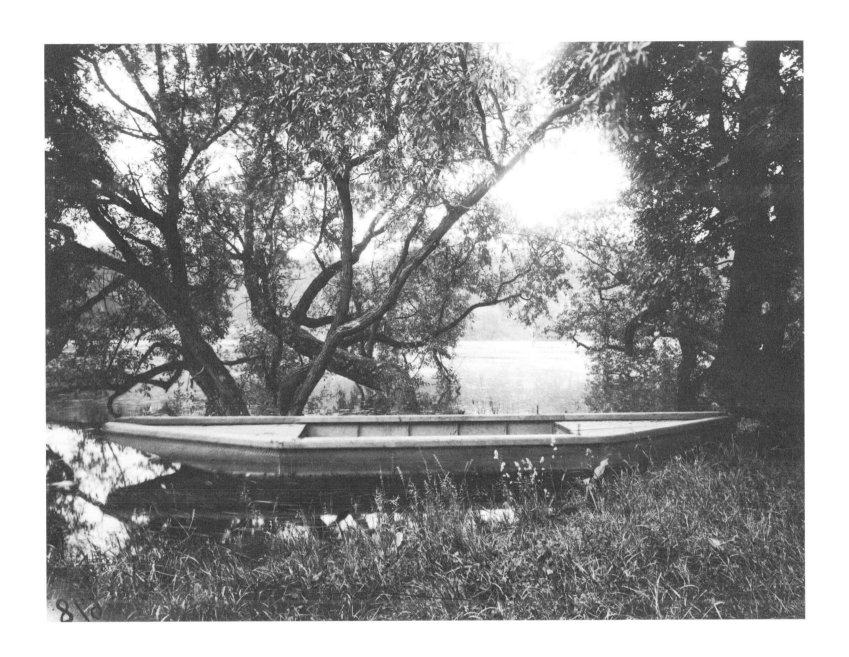

Bill Brandt

CHRIS STEELE-PERKINS
b.1947 British
Ted, Market Tavern, Bradford, 1977
Ph. 880–1980
23 × 24 cm

I remember in the fifties going to Tottenham to photograph 'teds' for an American magazine. I don't think those pictures were ever published. This picture reminded me of that assignment. What is interesting about the portrait is that the mirror appears to have photographed the boy. You forget the presence of the photographer and see only the fine concentration with which the boy is combing his hair.

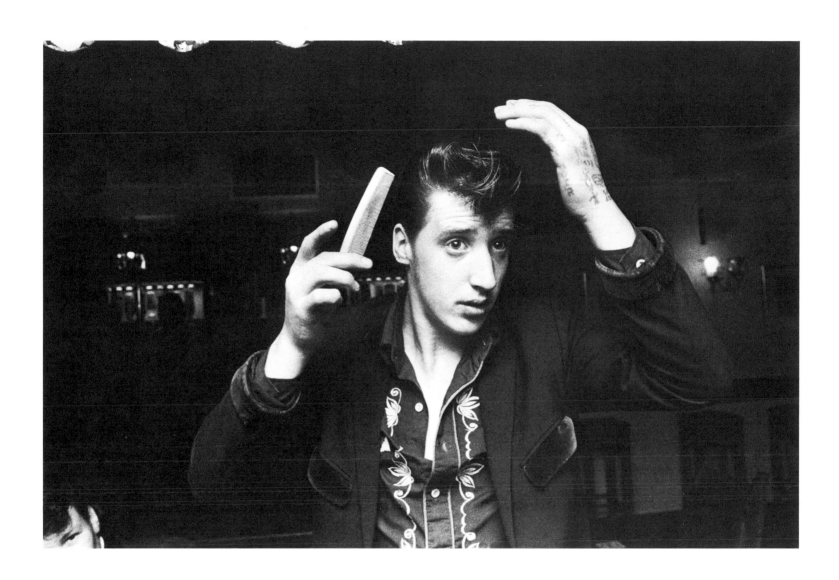

Bill Brandt

JOSEF KOUDELKA
b.1938 Czech
Prague, 1968
Ph. 1442–1980
23·1 × 36 cm

Perhaps this photograph is best left as a mystery but I have been asked to say a little about it. The longer you look at it the more ominous it becomes. It is terrible to know it was taken in Prague in 1968. I understand that a demonstration was planned for 12 noon one day during that August. Apparently the people were frightened of reprisals by the Russians or thought that their demonstration would be used as a propaganda coup for the counter-revolution. The wristwatch says 12.20 and the street is empty. There are almost no people, no trams, a few cars and the criss-cross patterns of the tram lines.

Even without a historical explanation the composition still strikes forcefully. It is mysterious and surrealist. Haunting, really.

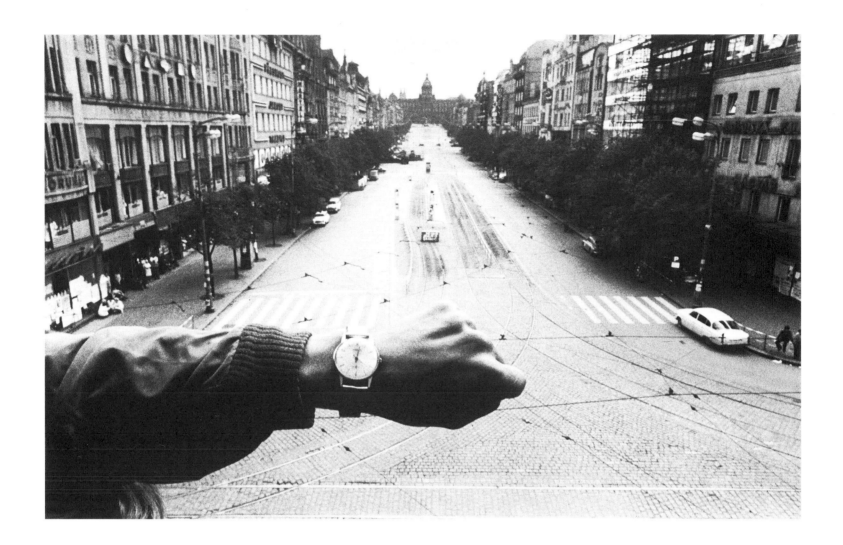

Bryn Campbell

W. EUGENE SMITH
1918–1978 American
Tomoko and Mother, 1972
Ph. 1052–1978
19·8 × 32·8 cm

The photographs that first made me understand what I wanted to achieve in photography were by W. Eugene Smith. This picture typifies his finest work.

The photograph that first made me aware that I did not understand what might be achieved in photography was this image by Mario Giacomelli.

Gene Smith's work inspired and reassured me. Giacomelli's picture haunted and disquieted me.

By the late fifties, when I came to know Smith's photography, he was already a legend, partly because of the quality of his picture essays for *Life* magazine and partly because of the battles he had fought over the editorial control of his material. What made him such a special influence was his passionate concern for both aesthetic and moral standards in photo-journalism. Other photographers may have shared his convictions but they did not crusade for them with the same fervour.

His genius was unquestioned and his craftsmanship immaculate. He committed himself emotionally and intellectually to his subject, scorning any pretence of objectivity. The first words of the prologue to his book *Minamata*, from which this picture is taken, are, 'This is not an objective book. The first word I would remove from the folklore of journalism is the word objective. That would be a giant step towards truth in the "free" press. And perhaps "free" should be the second word removed. Freed of these two distortions, the journalist and photographer could get to his real responsibilities.' As Smith saw it, his first responsibility was to his subjects and then to his readers. He believed that since his photographs sprang from his experience, his perception and his reactions, that he should have a controlling voice in their selection and presentation. To him, it was as much a duty as a right. Inevitably, he ran foul of his editors, unaccustomed to such rigorous integrity and with different views of their own roles. Eventually he resigned from *Life*, noting at the time, '…I cannot accept many of the conditions common within journalism without tremendous self-dishonesty and without it being a grave breach of the responsibilities, the moral obligations within journalism, as I have determined them for myself.'

It is hardly surprising that when such a man began to photograph the effects of chemical pollution on the people of a Japanese town, Minamata, it became a cause for him and not just another story. It almost cost him his sight. Company guards beat him up savagely after destroying his equipment. He had to be flown back to the U.S.A. for treatment.

The girl in this photograph, Tomoko Uemura, was poisoned by mercury before she was even born. No one knows if she is aware of her surroundings or not.

A caption is essential in order to understand the full significance of this image but the photograph has a power that words could never evoke. To me, *Minamata* symbolizes photo-journalism at its best.

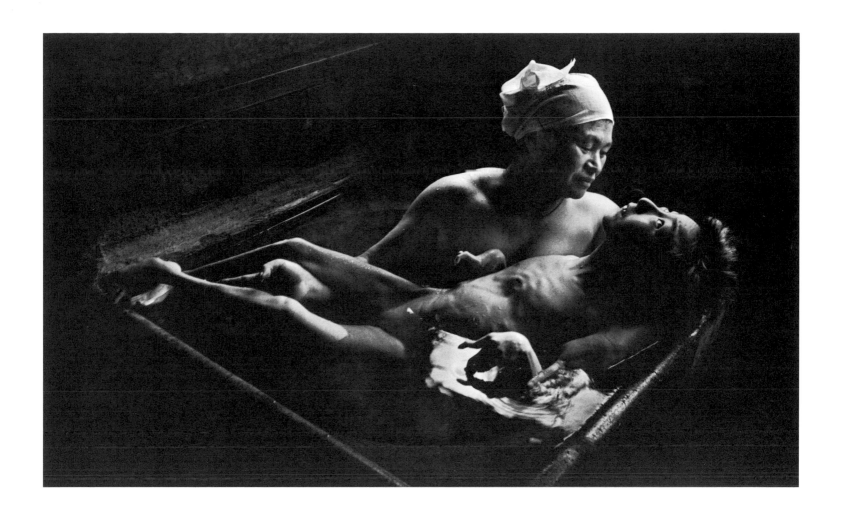

Bryn Campbell

MARIO GIACOMELLI
b. 1925 Italian
Scanno, 1963
Ph. 878–1980
29·6 × 39·5 cm

Words are of little help in trying to understand or to explain the effect of Mario Giacomelli's photograph. I saw it first in 1963, soon after it was taken, when I was preparing the next year's *British Journal of Photography Annual*. I had firm ideas then about the nature of the medium, its purpose, value, limitations and just about everything else.

The picture disturbed me and I was troubled at reacting so profoundly and so instinctively to a photograph without knowing why. (I am glad I had the sense to publish it.) It does not capture a moment of any apparent significance nor tell any story. There is no special beauty for me in the people, objects or environment in the picture. Where is the appeal? What gives it its power?

Perhaps it unsettles me because on one level of response I anticipate a story – because of the curious situation and strange dress – that on a more conscious level I realise does not exist.

Years later I was not entirely unprepared nor unsympathetic when a new generation of photographers explored the surrealistic possibilities of the medium so avidly. Giacomelli's picture also forced me to think more carefully about the purely visual values of the image; to enjoy photography simply for its qualities of description and to consider the extent to which photographers could evoke mood rather than merely capturing it.

I still marvel at the instinct that made Mario Giacomelli take a picture at that split-second. I am still disturbed by the result. And I still do not know why.

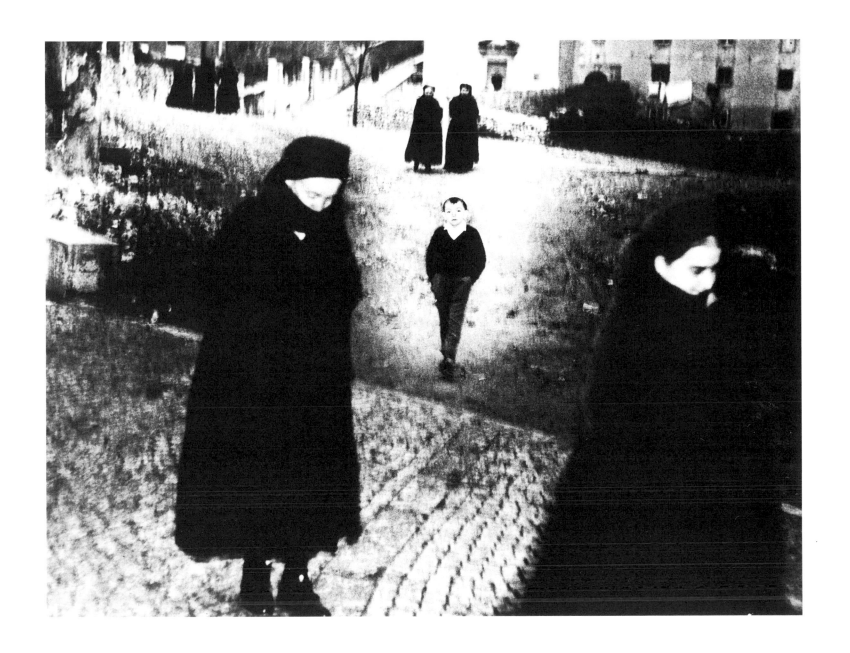

Sue Davies

MARTIN CHAMBI
1891–1973 Peruvian
Hacienda Owner and workers, Chumbivilcas Region, Peru, 1945
Ph. 876–1980
32 × 42·8 cm
Printed from the original negative by Edward Ranney

Although these two pictures are separated by less than thirty years in time, they are conceived and executed in totally different ways and evoke two completely differing if related responses. The formal group portrait by Chambi is full of security and harks back to similar studio groups made in the previous century. Sirkka Liisa Konttinen, on the other hand, reminds us of unfulfilled dreams and has taken her photograph at that 'precisely right' moment which epitomises today's photography. Having been lucky enough to have a secure childhood but one in which dreams played a great part, I feel that my response to both these pictures is probably very personal, quite apart from the admiration I feel for their formal qualities and for the work of their photographers.

Martin Chambi worked in relative isolation in Cuzco from 1920 until his death in 1973. His work came to light when the studio which is now run by two of his children was visited by the American photographer Ed Ranney. In 1977 Ranney returned, sponsored by the Earthwatch programme and together with a number of students worked on the archive, making contact prints from the plates and generally putting it in order. A series of exhibitions printed by Ranney was then shown around the world and this picture is typical of one side of Chambi's work, the formal portraits which he made of weddings, dignitaries and large groups. His own personal love was for the landscape of the area, including many views of Machu Pichu which had been discovered shortly before he moved to Cuzco in 1920.

The title of this picture, *Hacienda Owner and Workers taken in the Chumbivilcas Region of Peru, 1945*, reflects the formality of the portrait. The owner, in his black suit, is firmly in the middle of the picture with his employees neatly lined up around him. Only in the back row of the picture is there any sign of relaxation, with some of the lesser mortals peering round the shoulders of their companions and on the far left a latecomer hesitating at the edge of the frame. Everyone is taking the situation very seriously: it is a hierarchical moment and each person knows his place very well. The musicians stand proudly with their instruments, although those sitting in the front row have a slightly untidy appearance due to the slope of the ground. However, it is the gauchos with their elegant long leather chaps and neatly curled ropes who are the aristocracy of this community. While everyone else stares straight at the camera, one or two of them casually avert their eyes and are clearly sophisticated enough to take the event in their stride. It is a totally male society, there is no sign of any women who may be living or working in the Hacienda, and although the date is 1945 one feels the photograph could have been taken any time in the previous fifty years.

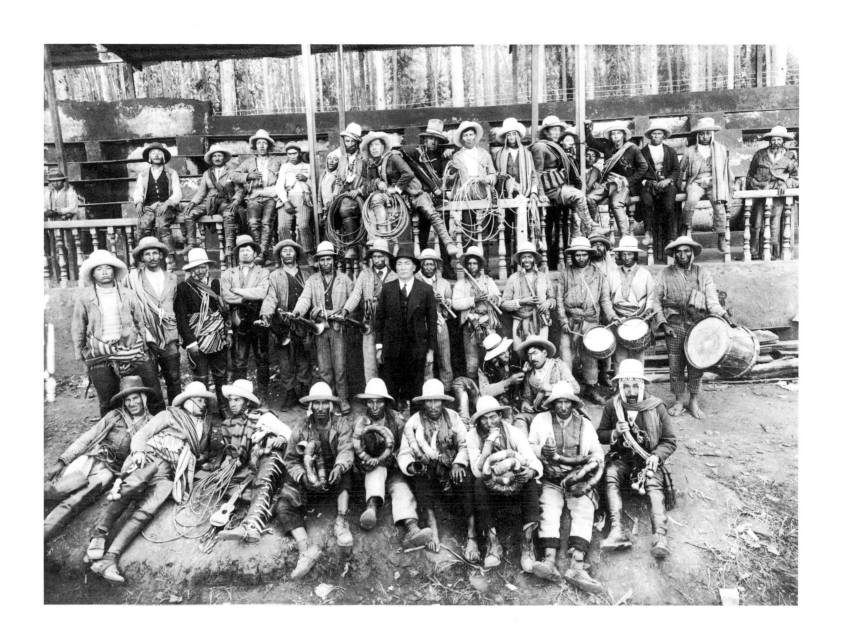

Sue Davies

SIRKKA LIISA KONTTINEN
b. 1948 Finnish
Girl on a Space Hopper, Byker, 1971
Ph. 273–1981
25·5 × 17 cm

In contrast Sirkka Liisa Konttinen's photograph, *Girl on Space Hopper, Byker, 1971*, shows one person, not yet certain of her place in the world, full of dreams and young enough to be sure they will all come true. It is this that makes the picture so poignant. All the formal qualities are there, in the composition, the bleak houses of Byker, the overcast day and the precise moment when the child is sure she is actually flying. No doubt she is as tough as any other kid in the street but just at this moment with the old sequinned dress pulled over her sweater and her hair flying, her own pumpkin might well turn into a gilded coach and carry her off to the ball – or to stardom on *Top of the Pops*.

Sirkka, who came to England from Finland in 1968, has been living and working in and around Newcastle upon Tyne since 1969. A member of Amber Associates who run the Side Gallery, she has won many fellowships and for some while organized a slide library as a money-making activity to support her photography. Recently she has been working with Amber Films and has just finished directing her first film for them. Jonathan Cape Limited are bringing out a book of Sirkka's photographs of Byker later this year.

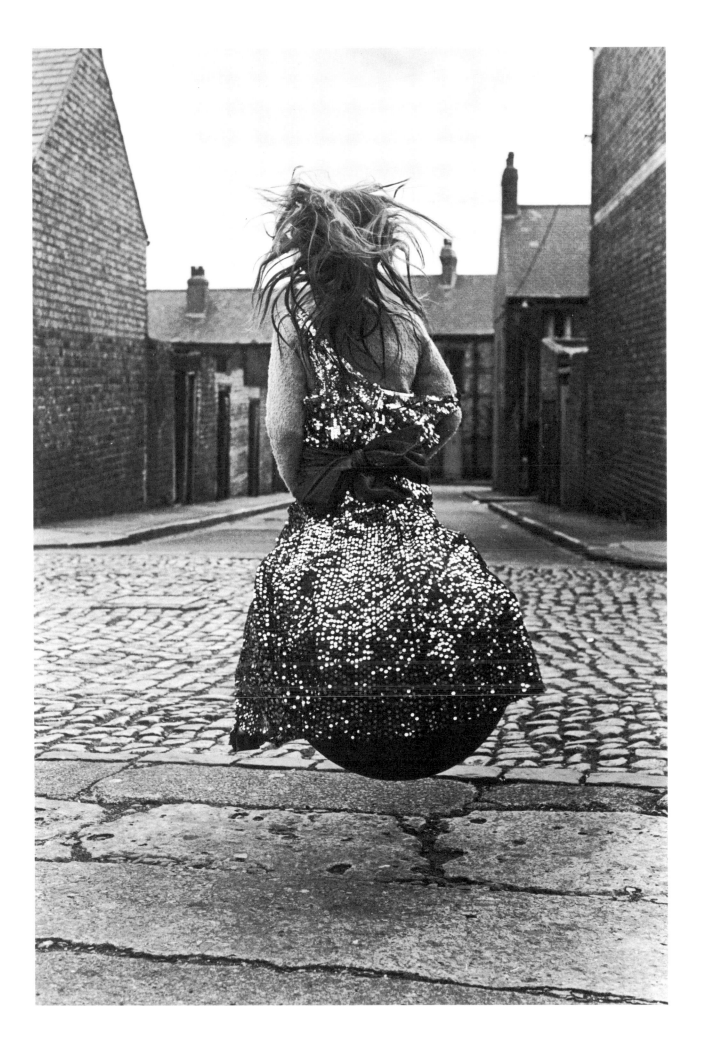

Ainslie Ellis

EDWARD STEICHEN
1879–1973 American, b. Luxembourg
Heavy Roses, Voulangis, France, 1914
Ph. 303–1982
20·3 × 25·6 cm
Photogravure by Jon Goodman, about 1980
© 1981 Aperture Inc.

The subject matter of these two photographs: some cut flowers and a group of men at a table under the chestnut trees, appears at first glance to possess nothing in common. I chose them because they embody, in a profound but simple manner, the significance of time in relation to all photography. Both, too, are masterly examples respectively of a still-life, and of acutely observed photo-journalism.

The photograph by Edward Steichen bears the notation *Heavy Roses, Voulangis, France. 1914*. Although seen only in a series of subtly modulated tones between black and white, it is the finest photograph of roses that I have come across. The texture of the petals is palpable and voluptuous. Yet there is something more. Much more. These are old roses, opulent and redolent of an age about to be shattered and dashed to pieces. They are the fragrant offering of that summer of 1914 before the impending sacrifice of millions of lives in this the First World War. It is impossible to look at this photograph, to see the date, and not sense the horror that was to follow. Yet it is an image which also recalls and enfolds an era that was captured in its richness and pathos by the two symphonies of Elgar and, I think, also by this photograph. A photograph that is at once symbolic and prophetic. For what Wilfred Owen was to call the 'monstrous anger of the guns' rumbles behind *Heavy Roses*, and the slow dusk and a 'drawing-down of blinds'.

A footnote to the roses themselves. It was good to photograph them for, like the era they represented, they would not be bred again. The horticulturists and hybridists, in their turn, would seek to 'improve' them out of all recognition.

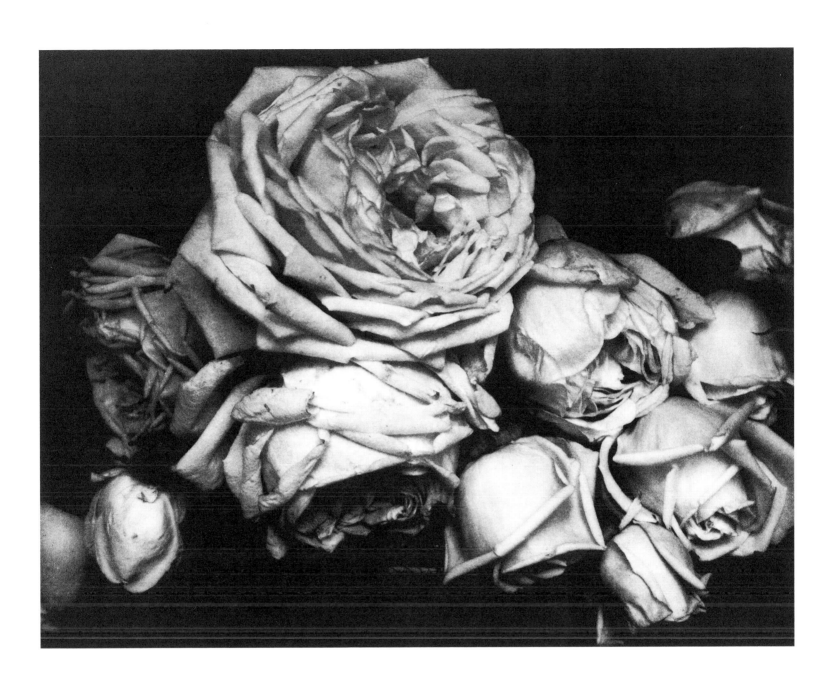

Ainslie Ellis

TIM GIDAL
b.1909 German, lives Israel
Munich, 1929 (Hitler in a tea garden)
Ph. 434–1980
24·8 × 17·8 cm

Tim Gidal's photograph is, at first glance, amiable enough. Four men are seated at a café table. The sunlight filters down through the chestnut leaves onto them. The place is Munich. It is the summer of 1929. A Socialist cabinet under Hermann Müller is in power in Germany. Allied troops that up till now have occupied the Rhineland have agreed to evacuate it. Who *is* this man with his hand to his face at the cafe table? Adolf Hitler. Although he has still to come to power he will, in the space of ten years, have torn up treaties, crumpled the face of Europe, and plunged mankind into the Second World War.

I find this picture to be a perfect example of photo-journalism at its best. It was taken for the *Münchner Illustrierte Presse*, one of those journals that laid the foundation of modern photo-journalism. Tim N. Gidal, who was born in Munich, was only twenty when he took the photograph I have chosen. He was a leading photographer, together with Felix H. Man and Kurt Hutton (Hübschmann), on *Picture Post* under Stefan Lorant between 1938 and 1940. He served in the British Army as one of its chief reporters from 1942 to 1945. He now lives in Israel.

As in Steichen's *Heavy Roses*, Gidal's photograph of Hitler under the chestnut trees is oddly foreboding. Even the expression on Hitler's face is already the one to be stamped into the minds of millions in the years ahead. Both photographs, on the surface, are of peaceful summer moments. Both presage and betoken a sinister rising of the curtain on events to come.

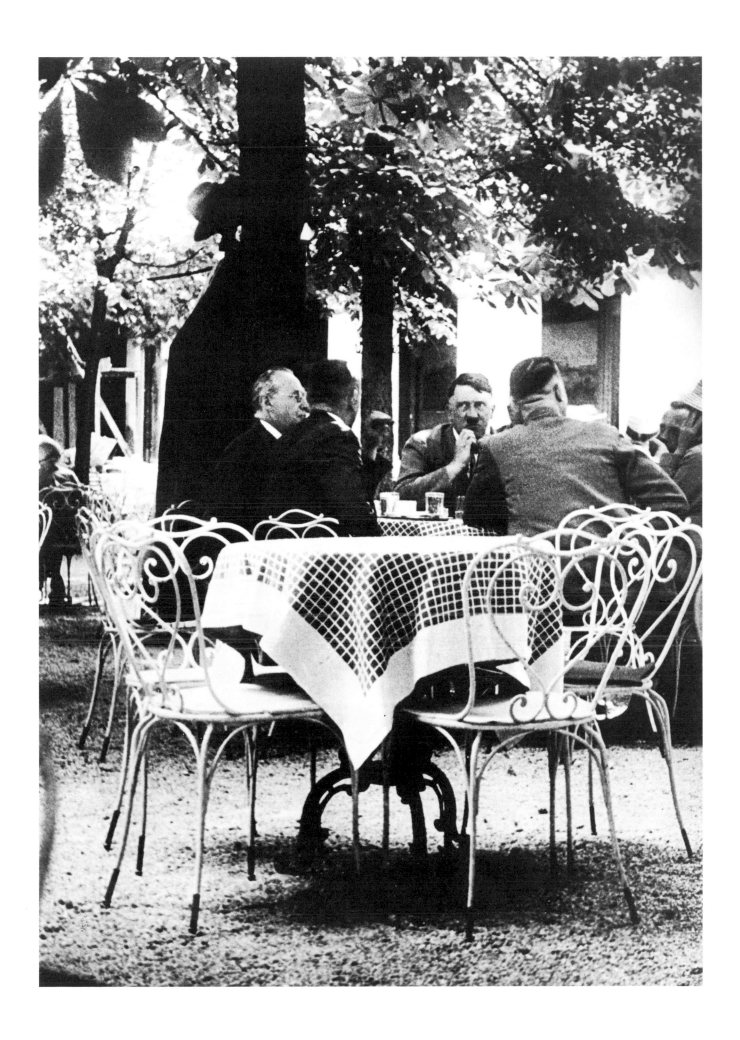

Harold Evans

JACQUES-HENRI LARTIGUE
b.1894 French
*The Beach at Villerville c.*1901–4
Ph. 308–1982
22·7 × 33·8 cm
Given by Olympus Gallery

I never cease to be enchanted and intrigued by Lartigue's photograph of the beach scene. Our hero, who is poised on what the old-fashioned would call a dividing third, looks like Edward VII, but what is he up to? Is he temporarily in disgrace with the ladies or cogitating on how he might remark to them that it is a very fine day and he wonders if he might share their share?

He is an immensely romantic figure, a head full of poetry and fine visions, the spirit of liberty by contrast with the dark conformity of the relentless troika on the right.

Does the position of the lady's hand and that of our hero suggest that we are witness to the act of goosing? But this is France and not Italy. And the man in the white suit for me epitomises imagination and freedom. He is reflecting. The others in the picture are merely talking and walking or chatting. Out of such a pause on such a balmy afternoon may be sprung a symphony by Delius or a novel by Zola.

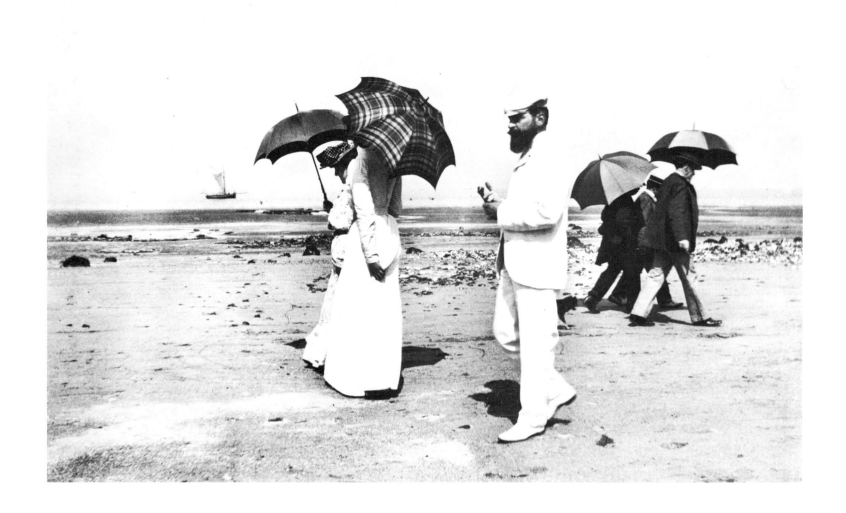

Hamish Fulton

U.S. NAVY
Weather Conditions, Antarctica, February 1970
From U.S. Navy aircraft for Scott Polar Research Institute
Radio Echo-Sounding Programme, Cambridge
Circ. 542–1975
23·7 × 26 cm
Given by Scott Polar Research Institute, Cambridge

Himalayan mountains – Antarctic desert. Seeing the photographs is not the same as being there, feet on the ground.

A photograph from the summit of the highest mountain in the world. No human habitation. An aerial photograph of Antarctica, a continent covering a larger area than the United States and India combined. No native people.

Two deadly places on the Earth's surface. Neither man-made. Two locations that are inaccessible to most people but whose photographic images have been 'brought back'.

Two photographs by specialists not involved in fine art photography. One by the U.S. Navy and one by the British mountaineer Doug Scott.

Filchner-Ronne Ice Shelf in West Antarctica. (An ice shelf is a large plate of ice floating on the sea and reaching thicknesses of almost one kilometre.) The photograph was taken from an altitude of 17,000 feet on 11 February 1970.

Doug Scott and Dougal Haston reached the summit of Mount Everest at 6 p.m. on 24 September, 1975. That night they survived the world's highest bivouac at 28,700 feet.

The Way of the White Clouds, by Lama Anagarika Govinda. The Sacred Mountain: 'This worshipful or religious attitude is not impressed by scientific facts, like figures of altitude, which are foremost in the mind of modern man. Nor is it motivated by the urge to "conquer" the mountain. Instead of conquering it, the religious-minded man prefers to be conquered by the mountain. He opens his soul to its spirit and allows it to take possession of him, because only he who is inspired or "possessed" by the divine spirit can partake of its nature.'

Both photographs are concerned with subject matter; the place, the conditions under which they were taken, not with composition or print-quality.

Two places at the limits of human existence. The death zone. Gustav Holm describes an experience of mystical rebirth among the Angmagssalik Eskimos: 'The first thing the disciple has to do is to go to a certain lonely spot, an abyss or a cave, and there having taken a small stone, to rub it on the top of a larger one the way of the sun. When they have done this for three days on end, they say, a spirit comes out from the rock. It turns its face towards the rising sun and asks what the disciple will. The disciple then dies in the most horrible torments, partly from fear, partly from overstrain; but he comes to life again later in the day'.

Both photographs show areas that are 'unspoilt'. If left unspoilt as monuments to harmony they can feed our deepest spiritual needs. By their existence. Only the passion of spiritual vision will deflect the blows of greed!

Deforestation of the Himalayan foothills. 'Hands off Antarctica'. (Bumper sticker produced by the Tasmanian Wilderness Society.)

F 31 U3N/GSR 381 - 2 II 70
FILCHNER AT VARIS RES 0192

0140

Hamish Fulton

DOUG SCOTT
b. 1941 British
Panorama from the Summit of Everest, Looking SSW,
Nuptse and Lhotse in Immediate Foreground, 24 September 1975
Barclay's Bank International/British Everest Expedition
C.25634
24·1 × 35·6 cm
C print
Given by the photographer

(Genesis. Chapter 2, verse 28.) 'And God blessed them, and God said unto them, be fruitful, and multiply, and replenish the earth, and subdue it: and have dominion over the fish of the sea, and over the fowl of the air, and over every living thing that moveth upon the earth.'

Kuo Hsi, eleventh-century Chinese master landscape painter: 'The din of the dusty world and the locked-in-ness of human habitations are what human nature habitu-ally abhors; while on the contrary, haze, mist, and the haunting spirits of the mountains are what human nature seeks, and yet can rarely find.'

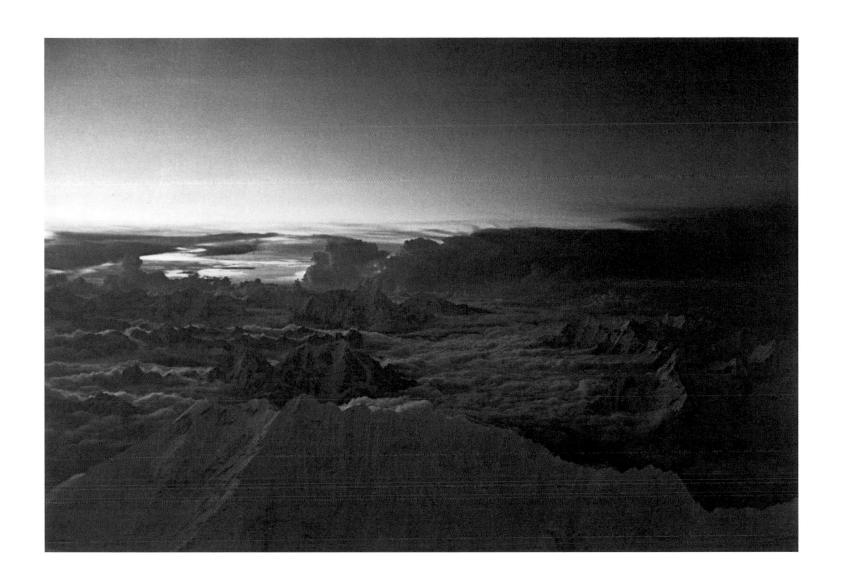

Margaret Harker

EDWARD STEICHEN
1879–1973 American b. Luxembourg
The Matriarch
(for Federation of Jewish Philanthropies, New York) 1935
Circ. 971–1967
43·5 × 35 cm

Steichen became the undisputed leader of photography applied to fashion and illustration between *c*.1925 and *c*.1938, during which period he was employed by Condé Nast. His work was regularly featured in American *Vogue* and *Vanity Fair*, two of the leading haute couture and fashionable magazines of the time. Contrary to popular contemporary criticism, Steichen did not sacrifice his vision and sensitivity as an artist to the world of commerce: he adapted his unique ability of aesthetic awareness to the demands made on him as a photographic illustrator and worked at the forefront of exploitation of the medium, both artistically and technically, to meet his needs. He produced great pictures through exploration of form, a thorough understanding of what can be done with lighting to control tonal relationships, and a superb sense of composition. An analysis of form in his photographs can be a deeply satisfying aesthetic experience. The reduction of inessential details is no easy matter for a photographer, so that Steichen's complete control over every detail in his photographs is truly amazing. He emphasized, subdued, created the illusion of depth and recession, concentrated the viewer's attention on features, form and line with subtlety and without resort to controlled printing (such as gum and oil transfer). He used straight bromide printing for all his later work. In spite of Steichen's attention to picture construction the viewer is never distracted from the 'message' or picture content – in fact, like all good art, the construction emphasizes the content.

Steichen hoped that 'the whole composition would have a certain majesty and, above all, the strength of something invincible'. It is a symbolic picture. The theme is as old as the Jewish faith. Steichen was particularly well qualified to handle such a subject with sympathy and power as he was for ever conscious of his own Jewish background. His choice of model was superb. So many viewers can relate to this seemingly ordinary yet extraordinary woman. She is dressed as most 'homely' elderly women of the thirties would be dressed. Her gnarled yet expressive hands rest on the Holy Book, fountain-head of knowledge and wisdom, but in spite of the prominence given to hands and book her facial expression demands our attention. The patience, suffering and endurance of the whole Jewish race seem to be summed up in that expression. The Steichen mastery of lighting ensures that the several parts of the picture are united but certain aspects are left to our imagination.

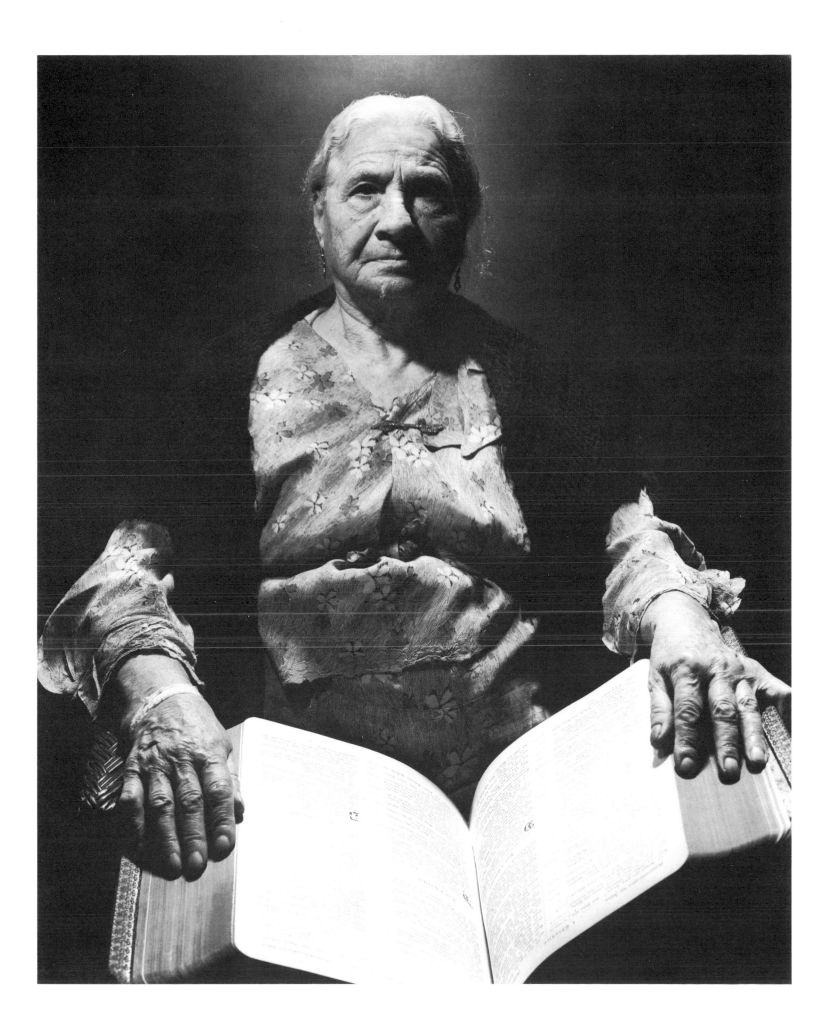

Margaret Harker

EDWARD STEICHEN
1879–1973 American, b. Luxembourg
Evening Dresses for Vogue, 1930
circ. 969–1967
35·5 × 28 cm

Steichen succeeded de Meyer as Condé Nast's principal 'in-house' photographer, specializing in fashion and celebrity portraiture. His style was almost directly in opposition to that of his predecessor. All important features are in sharp focus, the garments are shown to perfection, the models selected for their natural appearance: the general effect being one of elegance and charm. However, these photographs achieve far more than the obvious 'allure' necessary to promote sales of garments modelled or the magazine itself. Close scrutiny reveals the under-pinning aesthetic achievement in this photograph, in that the 'night and day' treatment or 'opposition' factor produces a fascinating picture. Steichen went for the optimum in tonal contrasts by placing light against dark whilst making full use of the mid tones. In this way he created the impression of roundness and depth. Although both girls are equidistant from the camera to preserve sharp focus the white garment is brought forward whilst the black one recedes. The different tactile and visual qualities in the white silk georgette and satin dress are masterfully displayed, and the swirl of the full skirt against the elegant close-fitting black dress, trimmed with ermine, is a stroke of genius.

Steichen never left any detail to chance. The jewellery was most carefully selected and worn to provide links between the two dresses – both girls wear identical bracelets, one wears drop ear-rings and the other a necklace. The trim pointed foot in the white shoe extends the body line of the girl apparently nearest to the front, and the angles of the heads provide another link, ensuring that both dresses are fully observed. The spray of flowers on the left adds the final touch (a typical Steichen ploy) to the balance and harmony of one of the most exquisite fashion photographs ever taken.

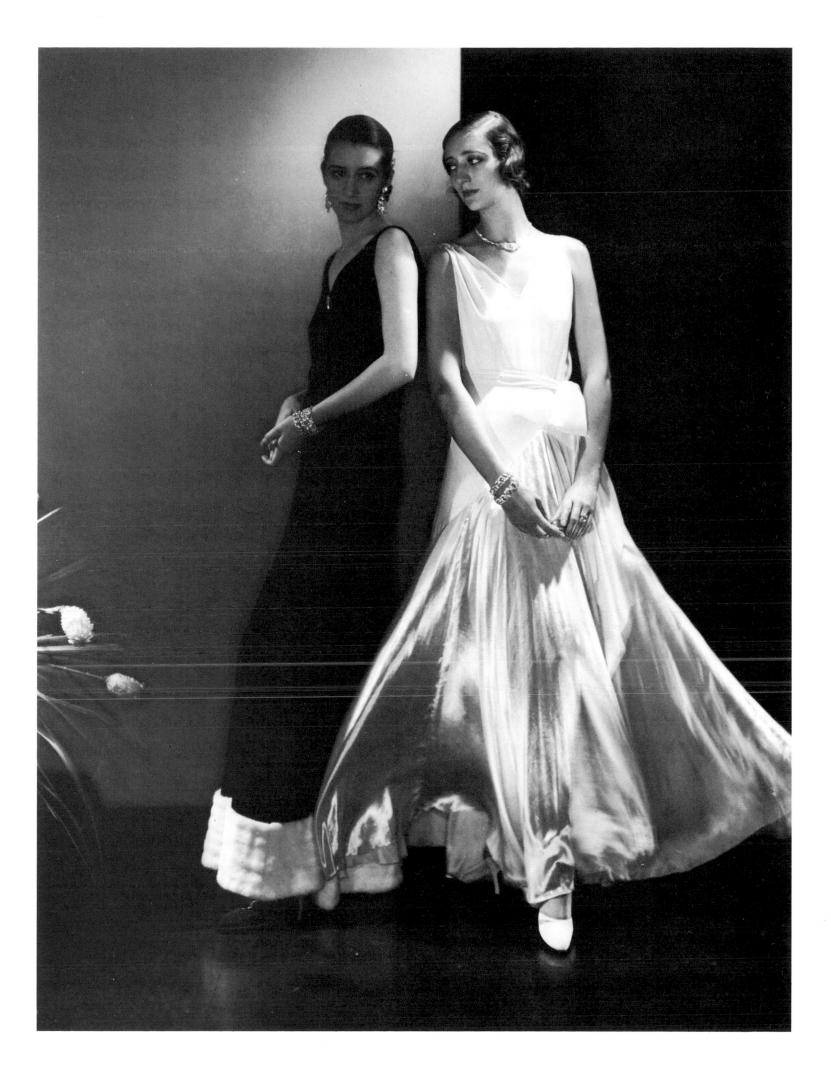

David Hockney

FREDERICK HOLLYER
1873–1933 British
Perseus and Medusa
From the *Perseus* series 1875–84
Ph. 2533–1898
30·3 × 27·5 cm
Photograph (platinotype) of a painting by E. Burne-Jones

When I did the small exhibition for the National Gallery two years ago called *The Artist's Eye*, I wrote a short essay about reproductions of pictures and I made the suggestion in it that photography was a very limited medium for an artist and that its best uses seemed to me to be the photographing of drawings and paintings. When photography did this it had, it seemed, become more real. The photographs became more real in the sense that they were not an illusion. They were a rendering of a flat surface upon a flat surface, because a photograph has no depth like a painting has no depth, literally anyway. I made the suggestion assuming photographers would pounce on me, but I overlooked the fact that they are not in the habit of reading short essays published by the National Gallery. But it wasn't all made in jest, really, the remark, because I had been thinking of the problem of our photographing drawings and paintings and I realised how people tend to forget that when you are looking at a reproduction in a book you are looking at a photograph. You are not looking at a painting. It is not a painting: it is a photograph. And there is in Walter Benjamin's famous essay about the work of art in the age of mechanical reproduction an insufficient awareness of this. It seems to me he overlooks something very important and very serious really, and that is that reproduction is not mechanical as he thought. Certainly since the time that the essay was written in the thirties reproduction of paintings and drawings is thought much more realistic. Skilful colour has been added. And in the end it seemed to me what Walter Benjamin overlooks completely is that there are skills needed to make reproduction whereas he suggests it is mechanical. His essay implies that there is no skill at all in it.

Well, there is skill: obviously there is skill, and I myself have noticed, when people were photographing my own paintings, that some people could do it better than others, especially in black and white. Black and white photography of colourful paintings is not easy. If filters are not used. If the photographer does not look at the painting carefully. If he doesn't sense what it is, certain colours in black and white begin to merge together, especially if they are on a flat surface (if he is photographing a flat surface), and blues and oranges for instance: if the blue gets lighter it would tend almost to look like orange in a black and white photograph unless you made some compensations for it. Well, this is an interpretive skill, it seems to me. Clearly the more the photographer loves the work the better the photograph will be. And this craft aspect of photography seems to me often to be overlooked in what we might call art photography or a show of photographs that a museum puts on. Alright, you might say they have got an exhibition at the postcard stand on the way out, *that* is a little exhibition and you can buy it as well. That is true; but nevertheless it doesn't tell you the name of the photographer, it is rarely on the back of the postcard, even on this reproduction of the Burne-Jones there is no mention of the photographer – you have to find out his name from somewhere else. Probably when it was done even the V & A thought it was all rather mechanical and didn't bother noting it down on the piece of paper, or anyway on the board it was stuck on. So I am choosing this photograph which I think in itself is very beautiful. It has a very beautiful and unusual surface. But it is also a photograph of a painting in progress. If you look carefully the drawing (the chalk drawing) is still visible on it. I don't know whether the painting was finished but if it was it would mean we now have a photograph of something that could never be made again, actually, putting it in another interesting category.

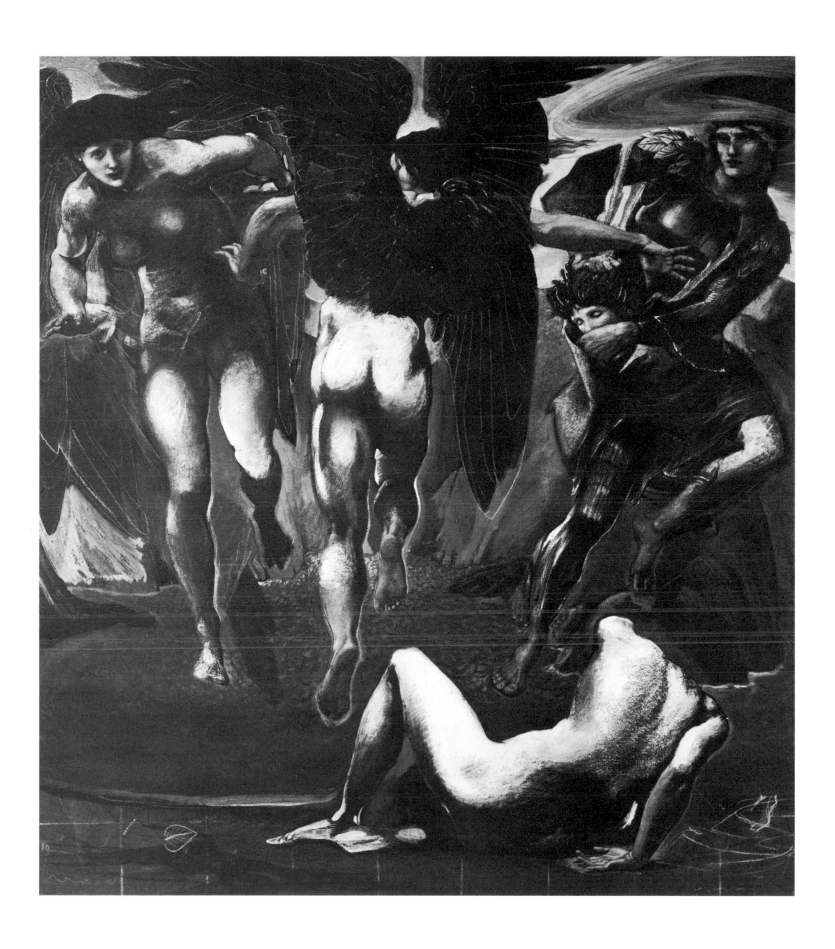

The other point about a photograph of a drawing or a painting that I made originally in the National Gallery essay was that this was the only way, it seemed to me, that the photograph could incorporate time into itself in that the time was in the painting in the sense that it took Mr Burne-Jones obviously quite some time to map out the painting you see here. And that is contained within the photograph. So you can scan this photograph in a different way from a photograph which is trying to make an illusion of depth of life in the street or room. The problem with an ordinary photograph is, it seems to me, this lack of time. After a while I think you can become very conscious of it. Maybe I am hyperconscious of it, or have become lately, causing me to make some photographic experiments. Photography is a medium which is essentially looking at the world in a fraction of a second and freezing it – which we never do. It is highly unrealistic. This is not the common perception of photography. The common perception is that photographs are highly realistic.

David Hockney

DAVID HOCKNEY
b.1937 British
Scrabble Game, Bradford, 1st January 1983
Ph. 1–1983
Photographic composite of C-type colour prints

In a way I am a hypocrite, I have taken thousands of photographs myself, but I never took it very seriously. It seemed to me it was a 'snap' medium in the sense that that was all you could do. The *time* business seems to get in the way of many things. It led to my having arguments with promoters of photography over the years, specifically the Curator of Photography of the Beaubourg in Paris.

After a number of days discussing photography with Alain Sayag I began to make some small experiments, first using the Polaroid camera with the intention of trying to make a photograph that had more *time* in it. As I began I suddenly realised one was hitting on a way of seeing that was of course more realistic in the sense that as I began to piece the pictures together, and seeing things in sections, I realised that this is the way we *do* see. This way we could produce a photograph that the eyes could roam about in, indeed, were forced to roam about in because they could not rest. They *had* to be shifting for the image to exist. I made about 120 elaborate photographs, complex photographs using the SX-70 Polaroid camera and I referred to them and exhibited them as 'drawing with a camera' because I thought they clearly related to drawing.

As I proceeded later on last year I moved on to using an ordinary camera, a 35mm or a 110 camera, an 'Instamatic' camera, to make pictures that are different from the Polaroid in the sense that they are drawing using your memory (because of course you cannot see the result of what you are doing for a day or two, unlike the Polaroid). As I proceeded with these, and they seemed to get more and more elaborate, I realised I was making pictures that were unlike other pictures because they were breaking the idea of looking through a 'hole' of photography – burdened with the old window idea of Renaissance perspective. As far as I could see Cubism had no influence, really, on photography or only the slightest superficial aspects of Cubism influenced photography. But there is a sense of *being there* in Cubism, an idea that you are not looking through a hole but that the café table is brought directly to your waist. Cubism was a means of getting closer to reality, closer to people.

As I pushed these thoughts and pushed the photography, or what I called photography, I finally made on the 1st January this year, this game of scrabble. The photograph took an hour and a half to take – to make the pictures with the camera as I played the game of scrabble with my mother, Ann Upton and David Graves (my mother won – as you can tell from the picture she is the only one truly concentrating, as I was in a sense putting my concentration into making the picture). It took one hour and a half to make the pictures and then about five hours to piece it together, so in all probability, what you are looking at is at least six and a half hours of clear time, time that is visible to you, that must be visible in some way. It is true, you can say the preparation to take another photograph took a considerable amount of time. That might be true, but it isn't always visible in the picture itself and if the time is not visible to us, then it is not there.

From a taped conversation with Mark Haworth-Booth, January 1983.

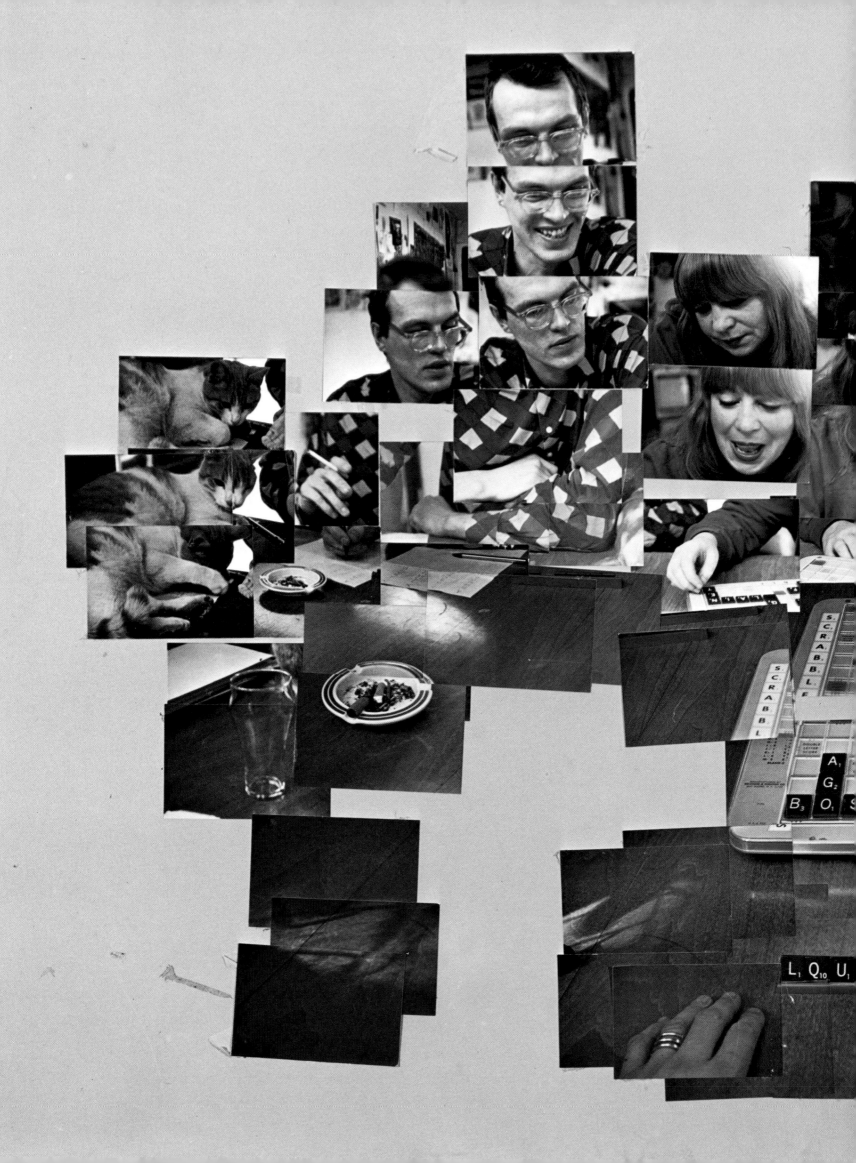

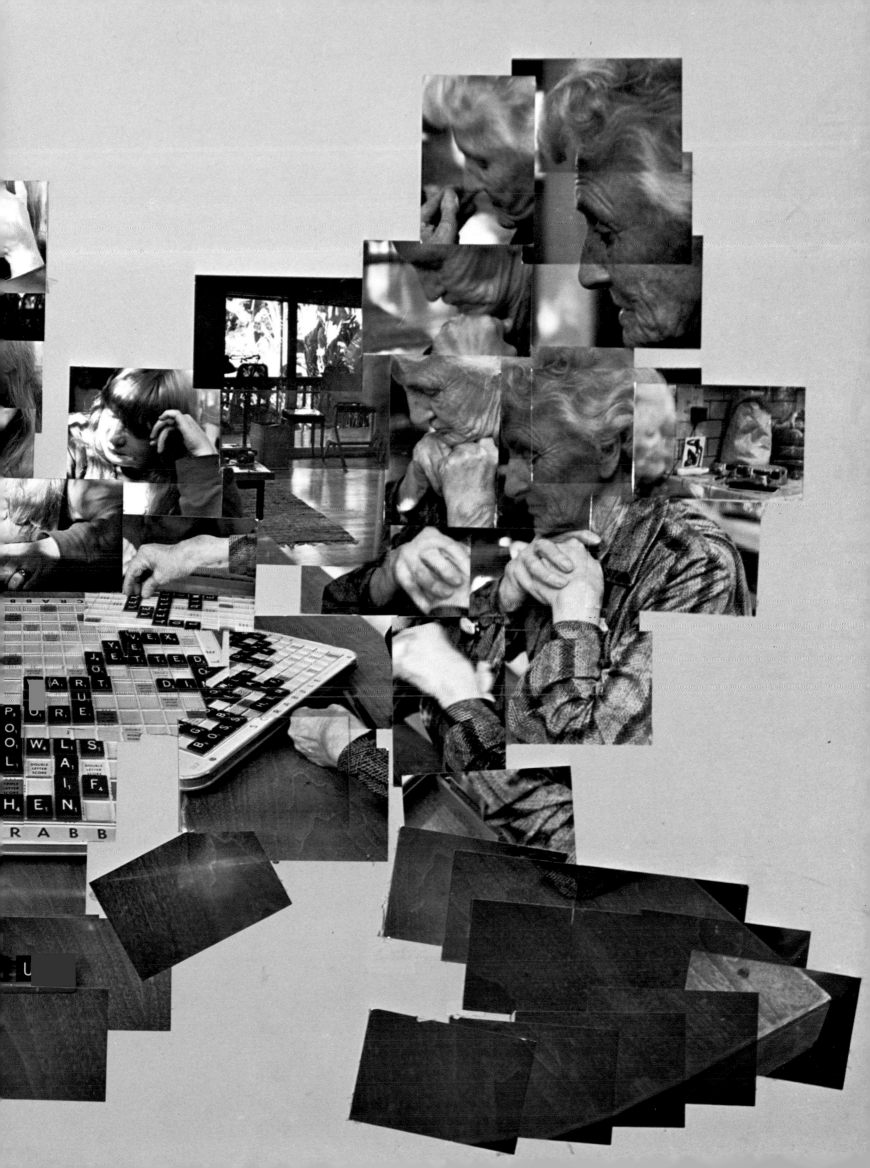

Mark Holborn

ROBERT FRANK
b.1924 Switzerland, American
Andrea, Pablo, Mary, Wellfleet, 1962
Ph. 354–1982
22·7 × 33·7 cm

'…with that little camera that he raises and snaps with one hand he sucked a sad poem right out of America onto film, taking rank among the tragic poets of the world.' Jack Kerouac

The voltage of a photograph is its ability to cut through a fragment of a second and write a legend. Style and sensationalism are low currents. We are arrested by those pictures which burn all the way to the edges. This requires discretion.

The myth of America is on a highway. Robert Frank found it on the jukeboxes along numerous highways. 'Highway 51 runs right past my baby's door, running from up Wisconsin way down to No Man's Land.' It was a sad song. Frank echoed its tone in his seminal book, *The Americans* (1958), which was greeted in its time as a travesty of photographic form. It was the work of a displaced man. Fourteen years later it was Frank who shot the cover pictures for The Rolling Stones' *Exile on Main Street*. His restless urgency in 1955 and 1956 produced many thousands of photographs which tapped that sense of motion and space, an American mythic vocabulary. Among his trademarks was the stamp of the American flag. The arc of a steering wheel, and graves and crosses by the roadside were also frequent insignia. Death was a partner in the myth.

Short lives and high adrenalin are legendary ingredients as is the rise of a star or the corruption of innocence. It was after twenty years that last December a California court finally ruled that there was no evidence of criminal action surrounding Monroe's death. The event is history like the motorcade in Dallas or The Bay of Pigs. Frank registers the day with simplicity. The beach is empty. It is the terminal point of the motion that drives from coast to coast. The family is his own – it is a disguised snapshot. His daughter is naked. Innocence trails the stripes across the frame. Then in tabloid letters is headlined death.

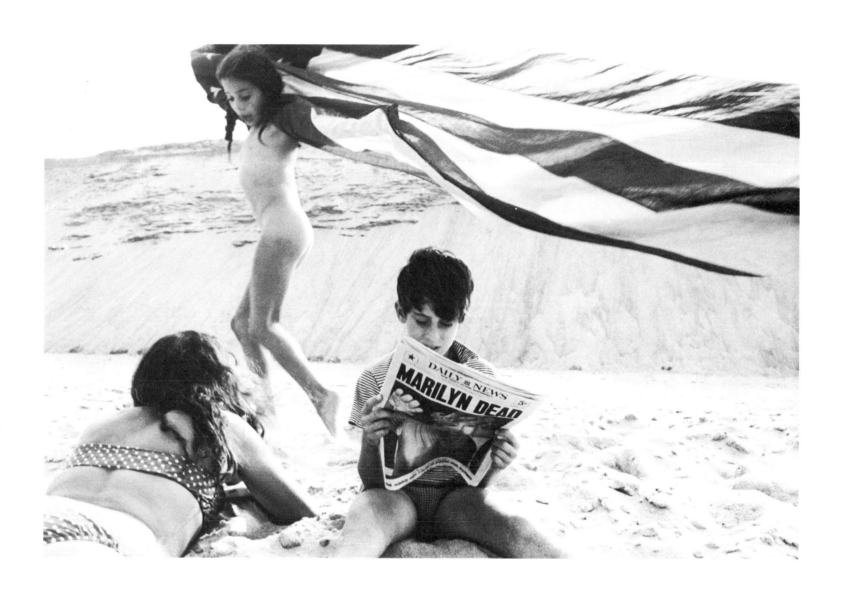

Mark Holborn

EIKOH HOSOE
b.1933 Japanese
Portrait of Yukio Mishima from Ordeal by Roses, 1963
Ph. 1239–1980
18·4 × 27·3 cm

Myths are further exaggerated by the ingenuity of the post-industrial decade, not diminished. Japan is the evidence. The writer Yukio Mishima defended a mythic lineage in a native identity. His final practice was not literature but warriorship. In a speech on the day of his suicide in 1970, a day on which he also delivered the last of his manuscript of *The Sea of Fertility*, a cycle of four novels, he challenged the national preoccupation with the GNP by asserting that the country was 'drunk with prosperity'. As well as a great writer, he was a man astride a volatile fault line between East and West, anachronism and bland internationalism. The manner of his death was the ultimate assertion of his tradition and elevated him to mythic hero.

In the months immediately preceding his death Mishima worked with the graphic designer, Tadanori Yokoo, on the production of Eikoh Hosoe's *Ordeal by Roses*, a monumental publication which appeared posthumously in 1971. The book was the final stage in Mishima's elaborate, morbid rehearsal, with the writer himself as the model. By exaggerating elements of Mishima's theatrical rococo extravagance, Yokoo elevated the final book to a form appropriate for the ultimate marriage between the dream of death and the substance of the flesh.

The final paragraph of his novel *Runaway Horses* describes the sunrise over a cliff as the hero, facing the sea, plunges the blade into his body. *Ordeal by Roses* started where Mishima's writing ended. Divided into five sections, it began with *Sea and Eyes*, followed by *Eyes and Sins, Sins and Dreams, Dreams and Death*, then finally *Death* itself. The book ends on a description of divine light from the *Upanishad*. Wrapped in an outer case of white cloth stamped with red characters, the opening of the book is ritualistic. The case folds out to reveal a full length nude of Mishima beneath Hindu reincarnation motifs. Roses sprout from his flesh. The book itself is bound in black.

The portrait with the single rose is a picture of polarities. The dark menace of his eyes is of a man on a determined course. The white rose bleeds into the white of his skin. The picture is stripped down to a final mask with a fierce and lyrical accusation.

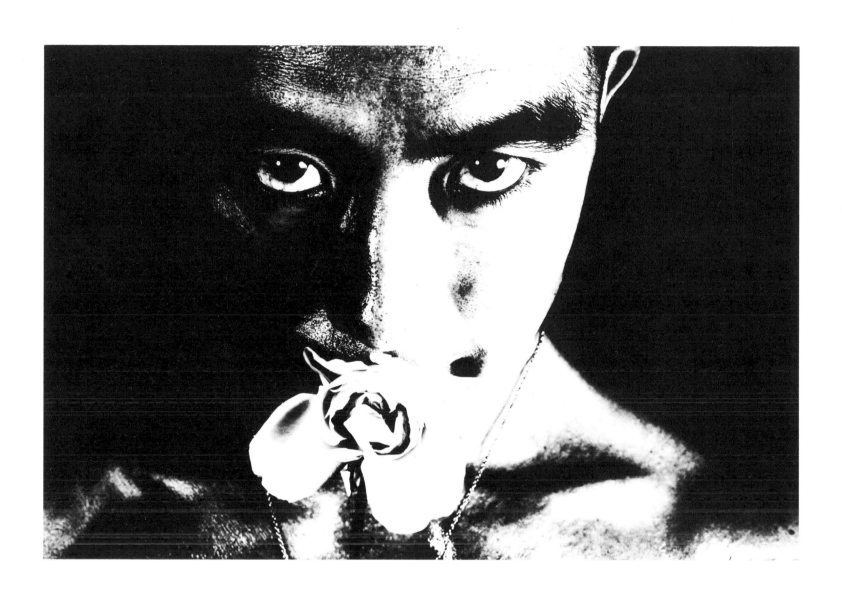

Tom Hopkinson

ROBERT DOISNEAU
b.1912 French
Le petit balcon, 1953
Ph. 254–1980
24·1 × 31·4 cm

There are photographers of grander achievement than Robert Doisneau, and many who are more renowned; but there is not one whose work is more enchanting, or which reveals a more tender sympathy for the human condition. A delightful humour lights his pictures, disclosed in the cross-currents of feeling which flow between one character and another, as though all are taking part in a comedy, the continuing comedy of daily life.

A young performer – her turn for the moment finished – has dropped down in the front row of the audience. Casually she leans against a nearby middle-aged knee, whose owner, hardly able to believe his luck, glances sideways hopefully, and the glance is enough to provoke his formidable wife.

In many of Doisneau's pictures there is the sense of an inaudible comment made by the photographer; in some, several small scenes are going on at the same time and in almost the same spot, but the participants remain separate, each character or couple absorbed in his/her own performance or relationship. Occasionally this comment is explicit; in one called *The Higher Animals, 1954*, a monkey, being laughed at by the onlookers, is the only dignified figure of them all.

Doisneau is a highly articulate man who has always known, through half a century of taking photographs, just what his values are and what he is seeking to express. 'I began taking pictures,' he says, 'because I was interested in my surroundings .' Not because he wanted to become a great photographer or artist, or because he had artistic theories which he aimed to put across. As a boy he looked at the world around him and was interested, though the surroundings of his childhood were not ones which most of us would find attractive. 'I was born in Gentilly, a suburb of Paris that was particularly ugly – though no more ugly than the other Paris suburbs. I am still a little sentimental about it, though now it is a place for sewage disposal.' His father worked for a roofing and plumbing firm.

Married at twenty-one, and needing to earn a living for two, Doisneau got work in a Renault factory, taking industrial photographs. When war came, after a brief service in the army, he lived under the German Occupation, hiding Jewish friends and using his technical knowledge to forge papers for escaped prisoners and people on the run. Always, whatever else he was doing, he took pictures and, for choice, the place he has always taken them is in the streets. Sometimes he worked for magazines; once he even did two years on *Vogue*. Sometimes he worked for newspapers; at other times on his own or as member of a group. But in the pictures taken to please himself the subject he is always looking for is 'the small second of eternity'.

Most people, Doisneau believes, have lost the power to see; their 'perception is dulled by watching too much television. Photography represents a return to the visual source. I think that when someone who is humble looks at things made by his own eye, the primordial tool, he understands them. The eye is the instrument of the poor. Photography is akin to this… Poetry and photography are much closer together than photography and painting.'*

*Quotations are taken from 'Dialogue with Photography' by Paul Hill & Thomas Cooper. Thames and Hudson, London 1979.

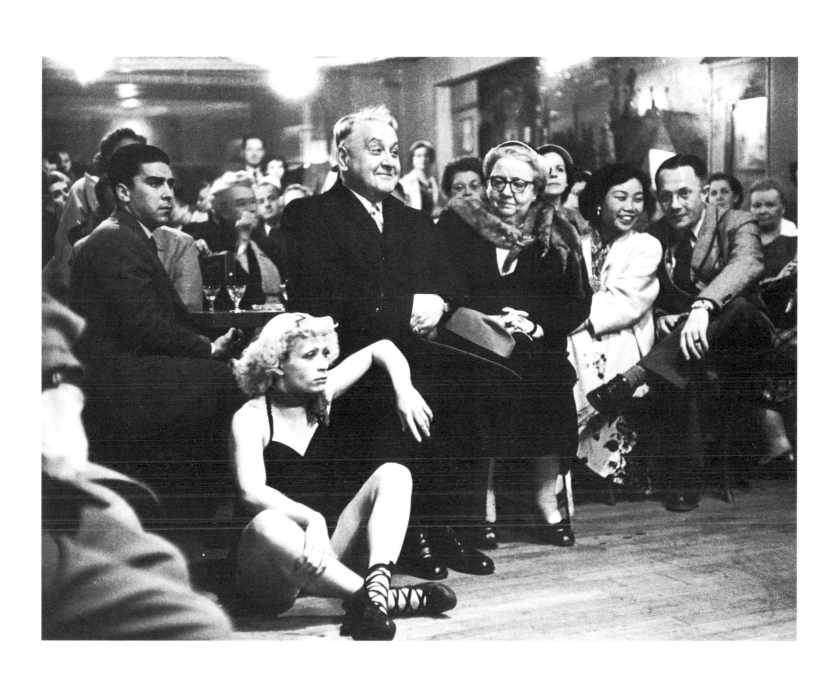

Tom Hopkinson

LOUIS STETTNER
b.1924 American
Paris, 1949
Ph. 1449–1980
38 × 29·7 cm

One of the oldest, fiercest clashes in photography is that between the 'hunters' and the 'fixers'. Hunters go out looking for their pictures: fixers largely make theirs in the studio and darkroom. Hunters believe that photography as an art-form has a specially close relation to the flow of life, and must, like life, incorporate an element of chance. Prowling about the world, seldom parted from his camera-weapon and with hands trained to act in instant accord with his eye, the photographer must be ready at any moment to cut precisely that cross-section out of time and space that will give him his magical result.

Among the 'hunters' are all photo-journalists, war cameramen, photographers of sport and action, natural history photographers, and lovers of fleeting effects of light and shade, reflections in water or shop windows, of everything that moves, floats, vanishes, gone almost before you know it's there.

'Fixers' regard photography from a quite different standpoint. To them photography is a technique for realising and making actual their inner fantasies, or for revealing some aspect of the physical world which they feel has been unappreciated or overlooked. Operating mainly in the studio, and manipulating their work later in the darkroom, they seek to control all factors – subject, lighting, atmosphere and scale. The final result will be their own creation, down even perhaps to some element of camera distortion which they have allowed for or intensified.

'Fixers' include portrait, fashion and still life photographers, photographers of architecture and record, many 'pictorial' photographers, and all who organise and arrange their subject matter to produce precise, previously-visualized effects. The distinction is, of course, not hard and fast, though it is real. Many photographers operate both as 'hunters' and 'fixers', and some forms of photography – such as documentary – may involve both hunting and fixing.

Of the hunter's art there can be few more dramatic examples than *Paris, 1949*, a street scene by the American photographer Louis Stettner. 'What on earth is it?' is the viewer's immediate query. Scrutiny reveals that the figure – enormously tall, pin-headed, in garb of mediaeval contrast – possesses four feet, the further two being smaller, neater. The tiny head stares sideways and a small body encircled by an arm can be made out, dimly outlined below the tasseled hood. A man, the father, is carrying his baby with his wife beside him – but what man, wife or baby look like we can know no more than we know where they were going or what happened to them since. They are just a passing apparition, caught and made lasting by the camera.

Born in 1924, Stettner is a photographer of wide experience, as photo-journalist, advertising photographer and portraitist. He has taught and lectured in American colleges; published several books; now writes a column in a photographic journal. 'Stettner,' Brassaï wrote, 'is fully aware that the photographer must not turn away from reality but, on the contrary, has to have a profound experience of the world.'

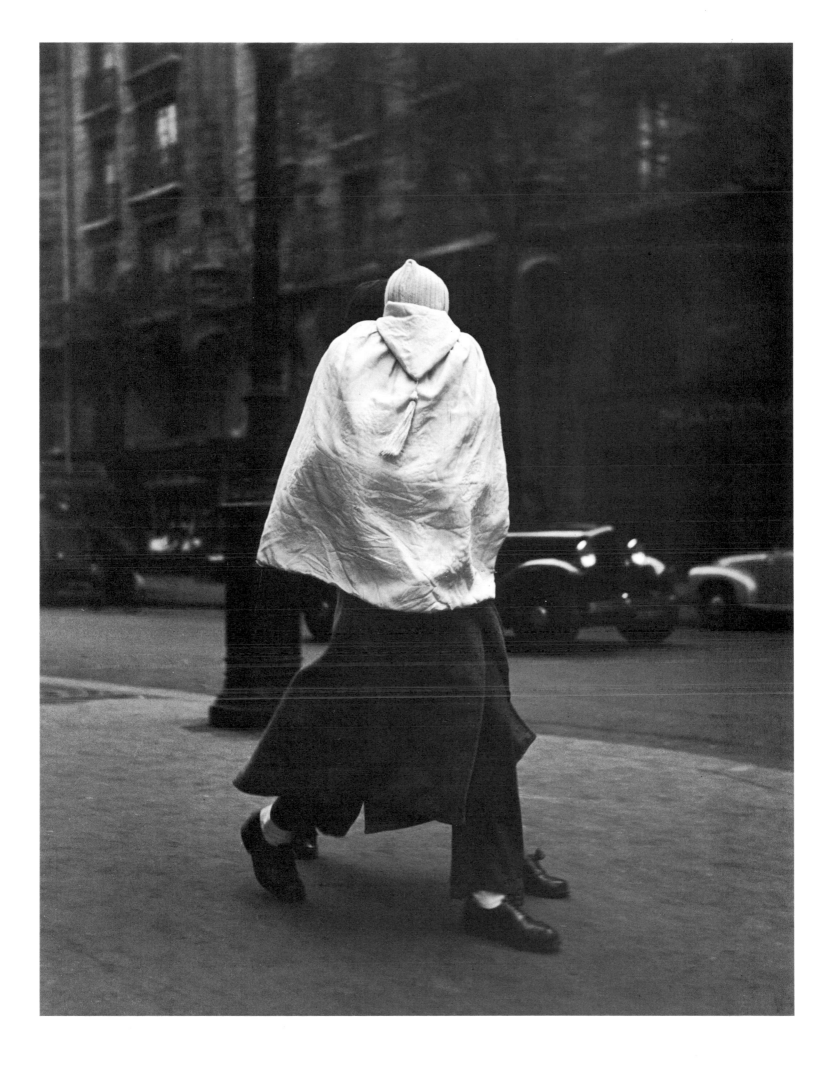

Ian Jeffrey

ROBERT ADAMS
b.1937 American
East from Flagstaff Mountain, Boulder County, Colorado
Ph. 355–1982
17·8 × 21 cm

Robert Adams' art is both austere and beautiful. There is no art like it at present, nor has there been since... since when? ... perhaps there never has been. Robert Walker, by contrast, is exuberant enough to stand comparison with Leech, or Cruikshank, or Rowlandson. But not exactly, for he deals in palpability as well as in exuberance.

Robert Adams' *The New West* was published in 1974, followed by *Denver* in 1977 and *From the Missouri West* in 1980, where this view from Flagstaff Mountain appeared. These are substantial picture surveys, often of urban and suburban sites as well as of the wider landscape, and although they don't show the earth greatly improved by Man's constructions they don't show it fouled beyond hope either. Recent exposé-photography brings the evidence up close enough to be overwhelming. Robert Adams stands back and shows site and situation, and site often redeemed by situation: clusters of prosaic buildings – in this case a city shining on its grid – barely present in wide, white spaces. There is something of the Sublime about his images of America, but that by itself is hardly new. The difference lies in the quite acute degree of attention that we are asked to pay. Look carefully into one of Robert Adams' pictures and you will find it alive with details, with traces of human habitation and action. Equally you will find pointers to seasons, weather and time of day. These signs may not always be thoroughly decipherable, but they are there and they invite scrutiny. Such landscapes with their immense spaces recall the endless vistas of romantic art in which we might lose ourselves. Here that sort of unfocused dreaming is not an option for long; other people's lives and that place at that time always intrude. On Flagstaff Mountain, how can I relate that dappled sunlight to the trees, and that band of shadow to the white light of the plain?

Contemplating in the mountains we have time to think. In the streets and in the thick of things a moment is no sooner registered than it is gone. Photographers, Cartier-Bresson in particular, caught spectacular instants and coped with the evanescent by ostentatiously fixing time. Robert Walker, observing in New York, notes such moments but copes differently, with more of a shout than a glance. His favoured moments are gargantuan rather than decisive. A connoisseur of the present and the palpable, his pictures are rich in weighty matter: a heavy hand, wristwatch, ring and cuff, modishly macho, dabbing at a powdered face and sequinned lips – delicacy 90% overpowered by beef and teeth. Characteristically coarse and overstated, Walker's pictures are, at the same time, as witty as any ever taken in the history of photography. Who else could make so much of a dab of powder back-stage? The medium, forever in danger of lapsing into fastidious good taste, is periodically saved by the arrival of such brusque talents: Weegee re-discovered, Lisette Model, Arbus at the end of her tether. There are other contemporaries expert in a similar sort of sharp, looming aesthetic, but Walker has the irony, the wit, the eye for extremes at the moment of their meeting.

Ian Jeffrey

ROBERT WALKER
b.1945 American
Rockette backstage at Radio City Music Hall, New York, 1982
Ph. 357–1982
34·1 × 23·3 cm

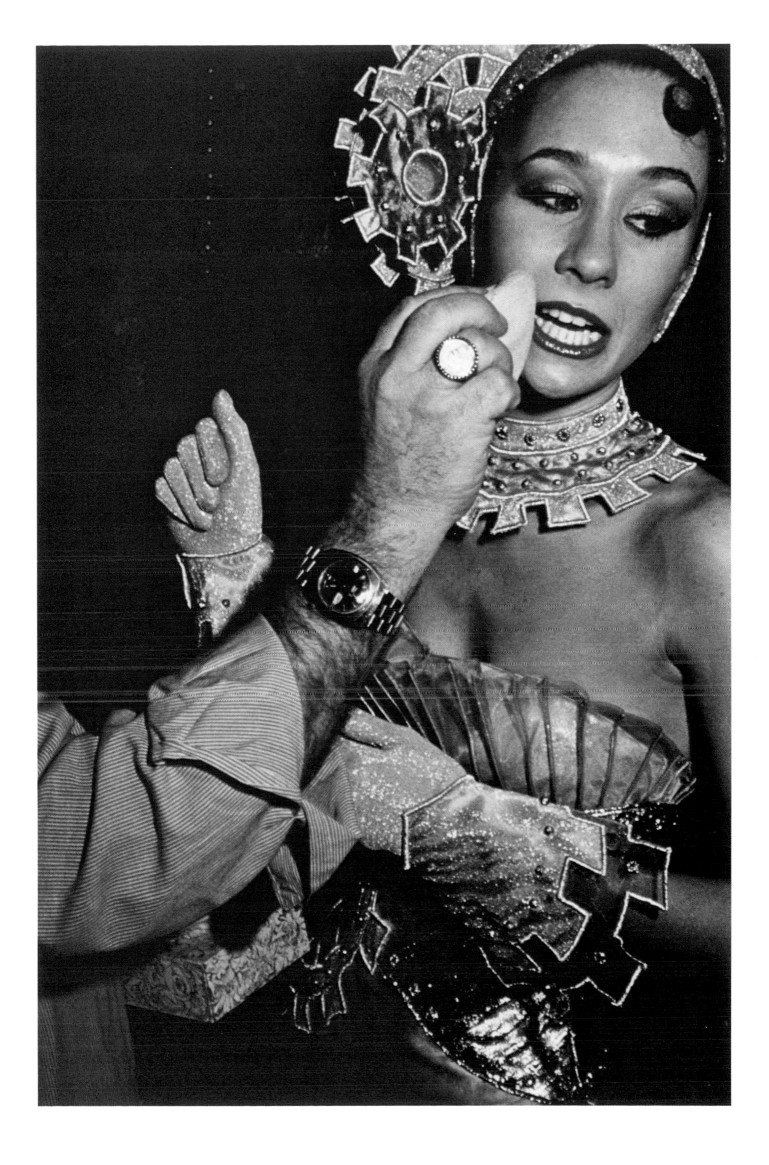

Chris Killip

DANNY LYON
b.1942 American
Uptown Chicago, 1965
Ph. 359–1982
22·3 × 24 cm

A hole in the lamp, cigarettes in the ashtray, a lucky dice on the wall, someone else blow-drying their hair under the iconography of Divine Love.

What a setting to show the fragility of human affection, but would you have recognised it, and could you have photographed it?

Danny Lyon, the hard man and risk taker, the most contrary of American photographers, stole from that split second the tenderest of images, and that could have meaning for us all. I'm glad that he did.

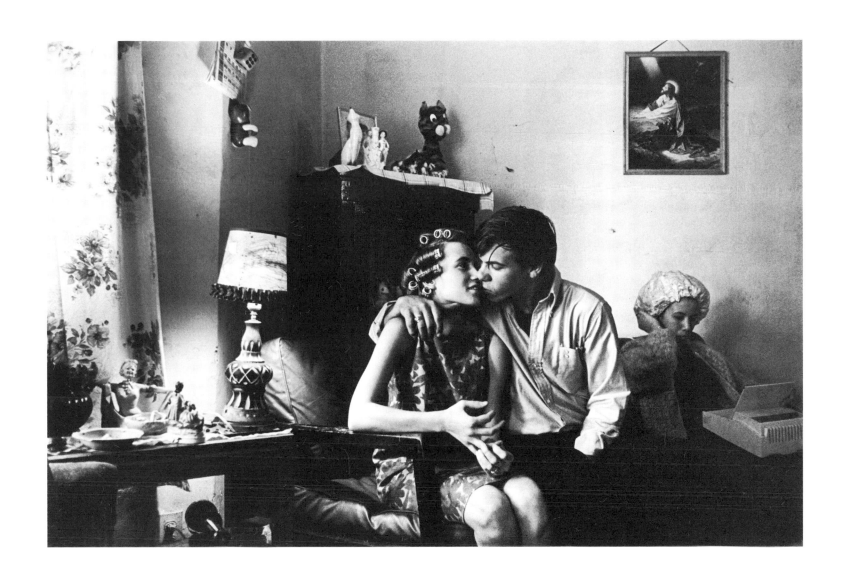

Chris Killip

ROBERT DOISNEAU
b.1912 French
La stricte intimité, 1945
Ph. 260–1980
28·3 × 24·7 cm

You walk the street, a newly married couple cross, no guests, no fuss, so ordinary a scene you could call it mundane.

To Doisneau it could have been all of this, but he also discovered something else: a newly married couple walking to their destiny.

His understating in the photograph of what he had seen is accentuated by the sense of distance, and gives credibility to a truly perceived moment in time. It's simply and directly recorded, with no sense of imposition; the subject dominates, and the photographer seems secondary. All Doisneau's best pictures have these qualities, this sense of affection and awe. Respect for what Orwell called 'The heroic, ordinary man'.

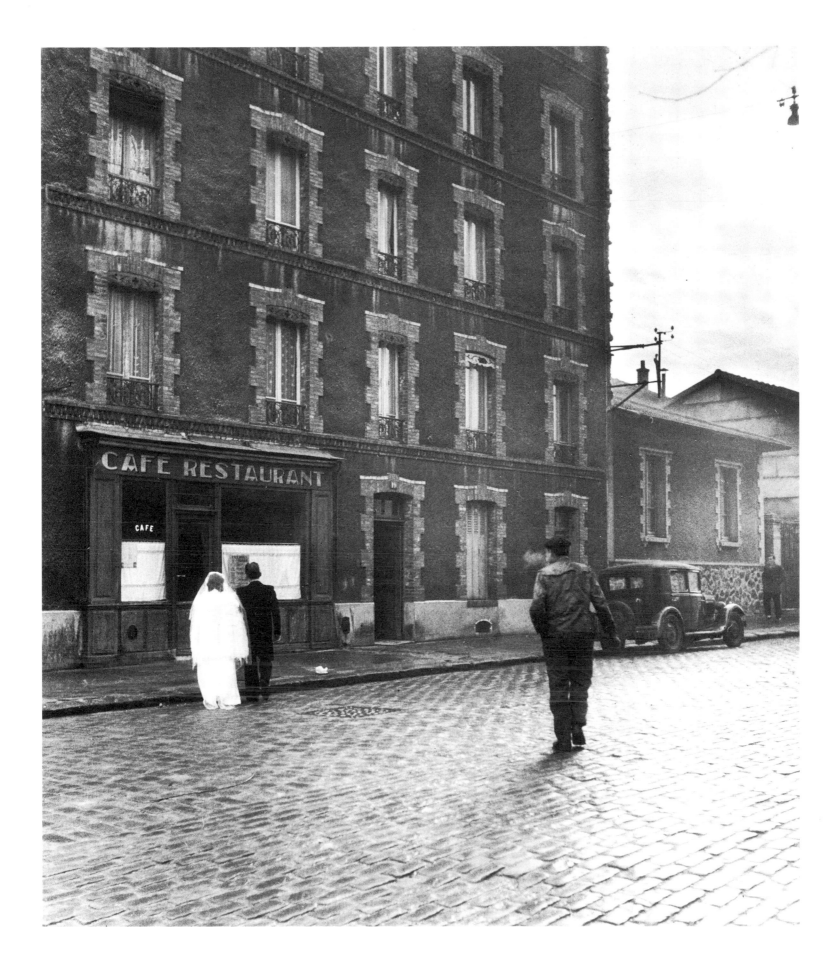

R. B. Kitaj

E. J. BELLOCQ
1873–1949 American
Storyville portrait c. 1913
Ph. 119–1979
20·3 × 25·5 cm
Printing-out-paper, gold-toned, printed from original negative by Lee Friedlander

One of the strategies of the poetry of photography which I find inspiring for painting is what might be called 'confessional'; a confession of what happened, day by day, heightened from life. A modern confessional poetics of painting is almost undream'd of, or has yet to be elaborated. I've had this masked woman on my wall for ten years and I never tire of wishing to know more than I already do about the way she lived when Bellocq snapped her moment. Painting as unashamed autobiography may just outreach photography, if not poetry, when it comes to naming facts of our days and giving up secrets.

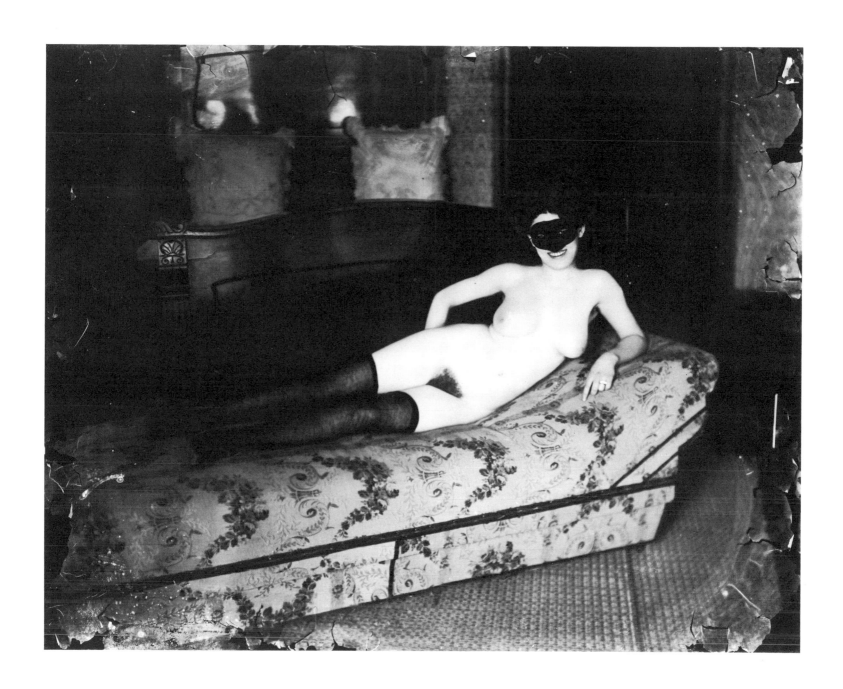

R. B. Kitaj

ROBERT DOISNEAU
b.1912 French
Coco, 1952
Ph. 360–1982
32·5 × 24·5 cm

My first choice was Doisneau's *Chez Freynes*, which is my favourite photo of all time. It shows an older man trying to chat up a young woman in a bar and was the subject, some years ago, of litigation, the sad result of which was that the negative was ordered destroyed. I'm told there are only two prints extant. So I chose this one instead, postcards of which I've been sending out since I arrived in Paris. The Paris of Doisneau is almost gone, like the Paris of René Clair and Henry Miller. Doisneau keeps prowling the streets, but he says he doesn't find the subjects like he used to.

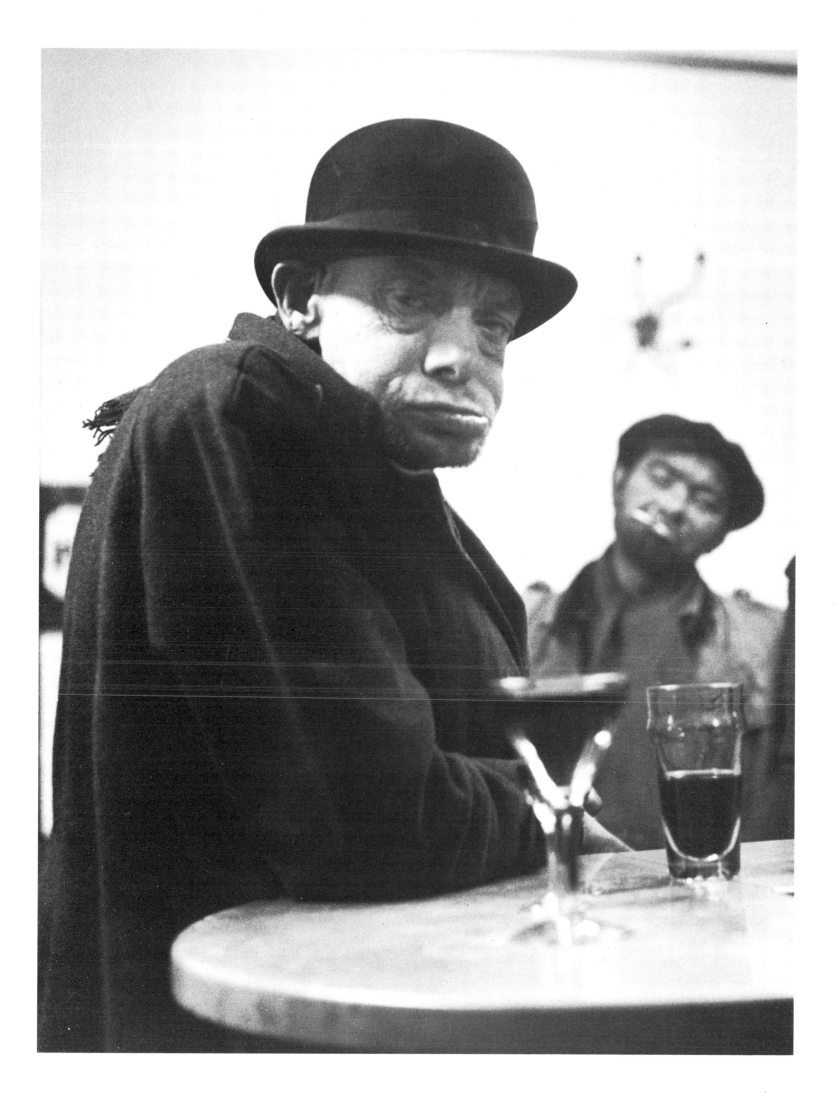

Valerie Lloyd

WALKER EVANS
1903–1975 American
Bed, Tenant Farmhouse, Hale County, Alabama, 1936
Ph. 170–1977
18·8 × 23·5 cm

This photograph is pure America. Although it is 1936, and it speaks directly of the 1930s depression in its documentary style and through the wide range of greys which make up the picture on the silver chloride paper, nevertheless its components are symbols of the United States at any time in its history. It is the home of a pioneer: a log cabin, iron bedsteads and a total lack of clutter, of personal possessions. Only a gun; and that gun speaks right through, in life and fiction, from the days of the early white settlers to the present; through cowboys and law-enforcers to William Burroughs.

Perfectly framed, not in a pictorial sense, but including slightly more or slightly less space around the subject than anyone else would, a feeling of rightness has been created, which does not consciously frame the bed. The room is recorded with little vertical or lateral distortion, in spite of the lack of space and the wide lens. The underlying dynamics of the picture come from the grain of the rough wooden planks which make the cabin: its walls, its window and the slightly smoother ones of the floor. The room mirrors the wooden box of the camera itself, and the fine practical proportions of the bed advance at a strange, oblique angle across the room, both towards the viewer, but also sideways within the picture plane. The window shutter is closed against the heat and strong light of the Alabama sun, and it is the camera's flashlight which picks up the dull sheen of the metal bedframe, lighting the sheets as if they were phosphorescent and casting dark lines of shadows around their edges.

The sheets are coverless. They are dirty, particularly on one side, the man's side. The man that uses the gun. This cabin will have shaped the lives of its inhabitants, they will be taut and sinewy, permanently dusty from hard work on barren land. It is no place for individuals. The second bed does not quite overlap the first, nor is it parallel with it. Only a corner of it can be seen. The picture is not about that bed; except in so far as to tell us that the first bed is not a private one. In the same way, on the left of the frame, there is just enough of the door to tell us why the bed is set at such an odd angle: to allow the door to open.

When one's eyes have dealt slowly with all this, they come to rest on the gun, lying across two hooks made from twigs nailed to the wall. The flashlight, absorbed by the rough wood of the walls, is reflected back by the highly polished wood of the butt. In the gun there is precision, as in the camera; and the barrel of the gun seems to lengthen and curve as it points to a join in the planks of the wall, to where, through a crack, the relentless sunlight outside has found its way in.

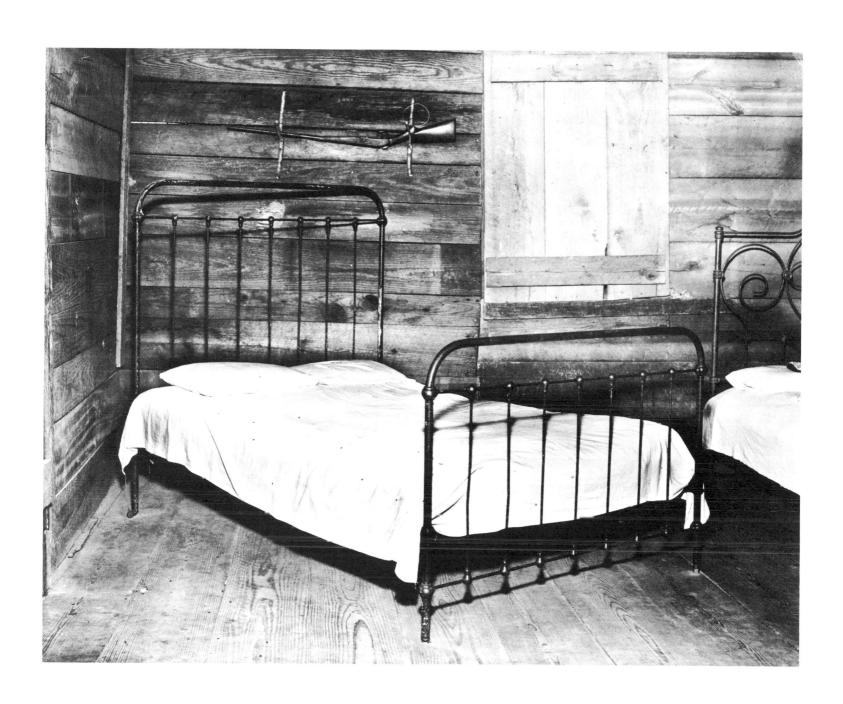

Valerie Lloyd

MAN RAY
1890–1976 American
Portrait of Lee Miller (modelling a bathing suit) *c.* 1932
Ph. 361–1982
29·6 × 19·7 cm

Compared to other fashion photographs of the time, this is a very plain image. There is no extravagant set, such as those of Beaton, complicated lighting arrangements as with Steichen, or clever, fashionable props, as in the pictures of Hoyningen-Huene. This simplicity is typical of one side of Man Ray's photography, which divides into two categories. Some, those generally better known, depend on a kind of fantastic trickery, either of a Dada or Surrealist nature, such as posing a model wearing a silver evening dress in a garden wheelbarrow, or achieved by photographic means in the darkroom: the superimposition of two negatives, the false elongation of a figure, the invention of 'radio waves' over the image, or the use of the Sabbatier effect to give a negative/positive aura to the figure. The other type, of which this print is an example, contain absolutely no tricks or dressing up of any kind. They have a feeling of deliberate understatement, and depend very much upon the model.

Here, a gentle floodlight is directed upwards, from floor level, lighting Lee Miller's legs evenly, from the front, but then falling off. It casts a huge soft shadow on the wall behind her, against which the top half of her body is silhouetted. A couple of spotlights overhead, and slightly behind, light the edges of her profile, the back of her head, her shoulders and her hands. If it were not for these spotlights there would be little tonal variation between her body and the background. As it is, the soft light on her legs seems to give her body a certain solidity, while the highlighted edges seem to isolate her hands, shoulders and head, like the extremities of figures in a Tanguy painting.

The photograph is taken from a very low viewpoint, around knee level, which has the effect of emphasizing and slightly enlarging the legs. Her hips are acknowledged by her right hand catching the light from above, but her breasts are left dark and invisible. Her left arm is raised from the elbow in a slightly awkward gesture with the hand resting on her left shoulder, almost as if she did not know what to do with it. It is a personal, self-conscious gesture, which recalls a later surrealist film, *Last Year in Marienbad*, in which the heroine held her arm in a similar position, but on the opposite shoulder, repeatedly throughout the film, as an expression of inward unease. Lee Miller's head is turned in profile, her lips darkened, and her hair shorn like a boy's. One is reminded at this point that the photograph was taken at the end of the Weimar period in Germany; the emphasis on the athletic pose, the flat bathing pumps and the shorn fair hair, suddenly begins to look slighly sinister, and the looming black shadow to take on a more threatening dimension. One thinks of Kurt Weill musicals and the shadows in *Dr Caligari*.

But this picture is not really sinister. There is something too real and healthy about Lee Miller's genuine classical beauty, the lack of tension in her body and the calm stability of her gaze. David Bailey said he thought this picture failed as a fashion photograph because her hands are too big. He is probably right, but that is also what makes it an interesting picture. Lee Miller may have been one of the most beautiful women in Paris, but her hands show that she was also one of the most capable. Just over ten years later her strong physique stood her in good stead when she joined the American liberating forces in Europe, with her cameras. She lived rough with the troops through some of the worst fighting, and produced unique photo-reportage for *Vogue* magazine – much to their surprise. But, back to the picture, it is Man Ray's insistence on lighting her hands (for there is nothing accidental about any part of this picture) which, together with other small things already noted, and perhaps with surrealist intent, undermines the commerciality of the fashion photograph, but thereby gives it a greater value.

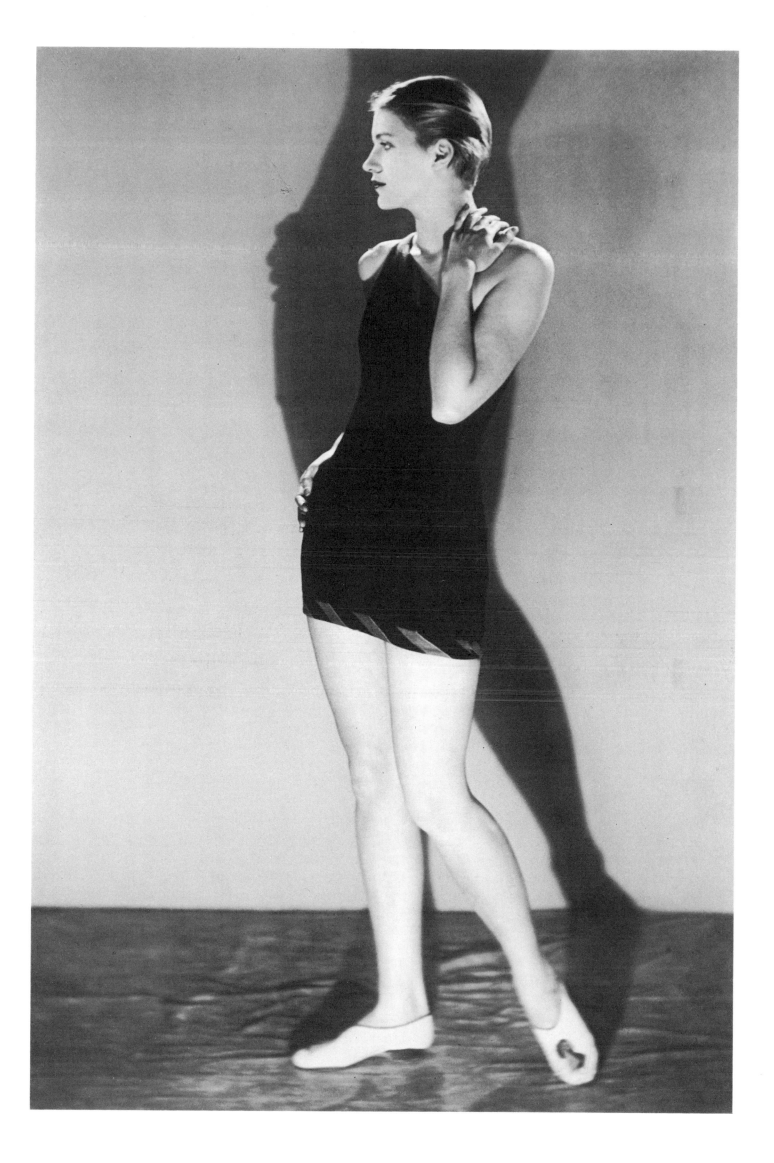

Donald McCullin

DMITRI BALTERMANS
b.1912 Russian
Looking for Loved Ones, Kerch, 1942
Ph. 362–1982
24·2 × 29 cm

My choice of Dmitri Baltermans' important photo of a massacre in the Crimea, which took place in Kerch in 1942, shows grief-stricken relatives searching for loved ones who have been murdered by the Nazis. This photograph graphically outlines the suffering and pain which was paid by the Soviet people during the Second World War. This print, which has been especially sent from Moscow, does not in any way belong to the school of art, even though it has all the qualities of classic drama and composition: we cannot disassociate from it a strong resemblance to past historical painters who depicted wars.

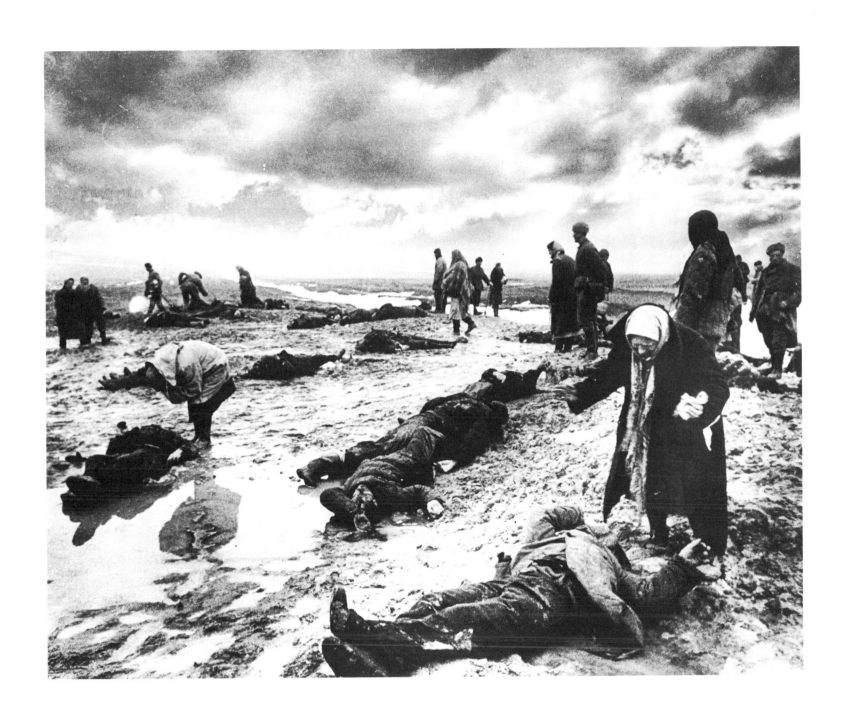

Donald McCullin

SIR CECIL BEATON
1904–1980 British
Mrs Rhinelander-Stewart, 1933
Ph. 190–1977
25·3 × 19·7 cm

In complete contrast, my choice of Cecil Beaton's beautiful and decadent portrait of Mrs Rhinelander-Stewart taken in 1933 could almost provoke anger that these pictures should be allowed to sit side by side. The world cannot exist on truth alone; occasionally we must allow the Cecil Beatons to create gardens of Eden. He obviously adored photographing women in a style as if creating flower arrangements, and I get the impression that women were thrilled by this privilege and trusted him. His prints are excellent because his lighting effects were enormously creative, though this particular print has gold discolorations (which don't harm the image at all). Baltermans' print, which has arrived scratched and unretouched, is as it should be – giving us the smell and reality of that tragic day in Kerch.

The highest tribute we must pay these two photographers is to their integrity, even though one was photographing tragedy, and the other showing us the privilege of being born beautiful. They allow us at the same time to be a witness in a fast-changing world.

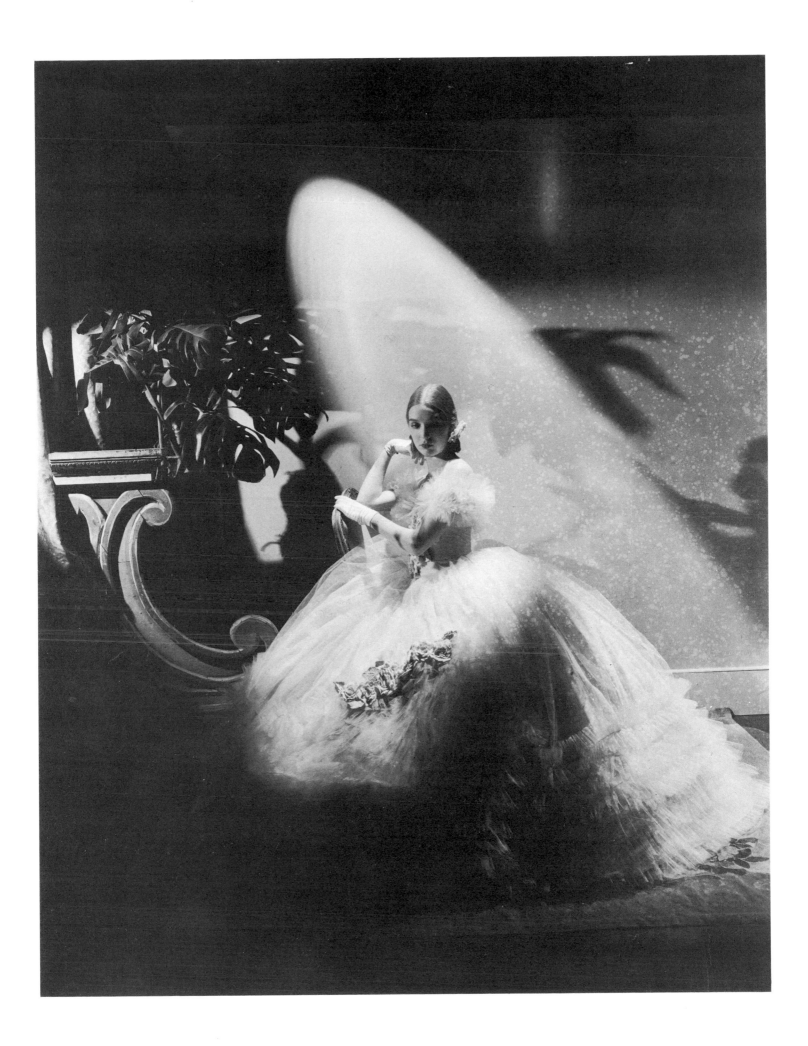

David Mellor

PETER ROSE PULHAM
1910–1956 British
Leonor Fini, 1938
Circ. 3–1977
19·2 × 20·5 cm

In the space around this towering woman everything seems duplicated, but unfixed; even in the sight and portrayal of herself. The activity of portraiture, in an image where photography and painting are fused together, seems at stake and brooded over. Peter Rose Pulham's portrait appears like an inquiry into the metaphors and fantasies that compose portraiture itself; most particularly the depiction of women.

To begin, the spectator is granted an *intimiste* perspective, a voyeur's look upon Leonor Fini: one she might acknowledge in her gaze to the mirror. This gaze seems to close a circuit of observing, exhibiting and simultaneously painting herself, in and on the mirror's surface. Within that frame her face is duplicated and re-duplicated, – *en abîme.*

She is represented representing herself: as a Narcissus who paints upon her reflection transformed into an immaculate canvas. And there is meaning to the style in which she is represented. A looming, fantastic, fatal woman in black, in effect, a fetish. It is a portrait supported by a revivalist genre of the late thirties and forties; Romantic, often Victorian, melodrama reconvened in wide angle, private spaces; a genre which contained Welles's early films, *film noir*, and Brandt's forties portraits too.

Leonor Fini is located in this sort of imaginary space, at the focus of our fascinated gaze, amidst askew and toppling walls and doors and chairs. It is the space of *Wuthering Heights*; not the original novel certainly, rather somewhere between the novel's remaking at the hands of Hollywood director William Wyler in 1939 and those illustrations drawn five years earlier by the close colleague of Fini and Rose Pulham, the painter Balthus.

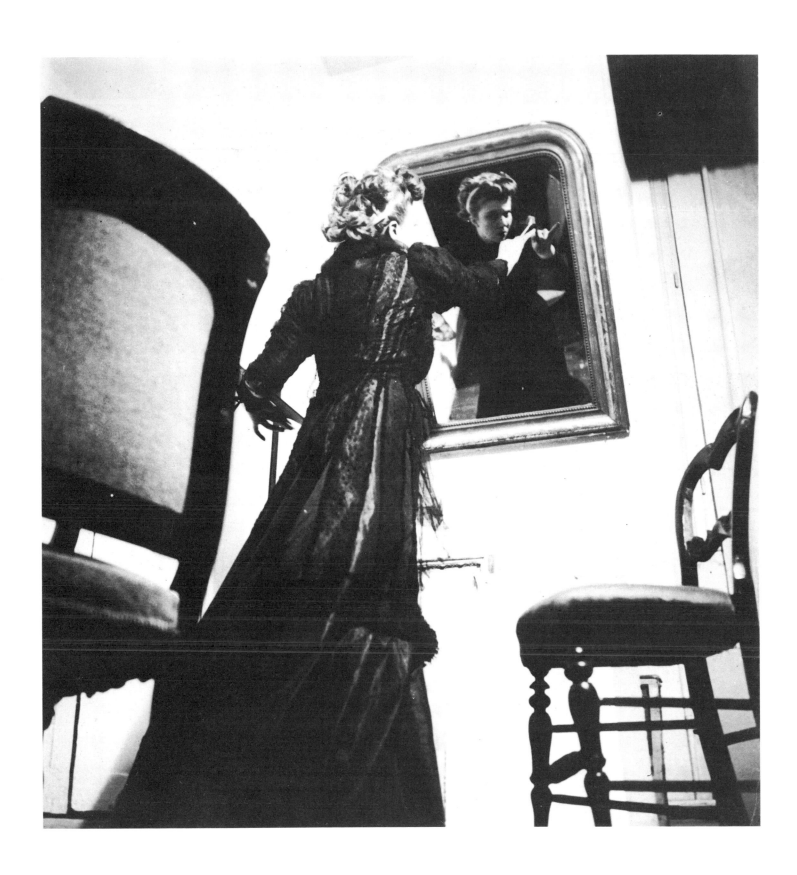

David Mellor

DAVID BAILEY
b.1938 British
Jean Shrimpton, New York, 1962
Ph. 363–1982
50·8 × 40·6 cm
Given by David Bailey. Illustrated by courtesy of Condé Nast Publications ©

Signs of Britishness; signs of New York-ness; 1962, the moment of Pop. This is a fashion photograph which juxtaposes cultural structures, offering them up flatly like the flat surface of the picture. An urban fragment already cut up into regular geometrical sets.

This is Betjemanesque Britishness – (a young woman, legs akimbo, teddy bear retained) – directly addressing *Vogue*'s British readers from the grid of New York: a sign of innocence asserted within the worn, collaged street environment.

In 1962 the theme of Americanization and its pressure upon systems of representation in British painting came to the fore. David Hockney's record of a visit to the USA, the series *The Rake's Progress*, was symptomatic. Derek Boshier generated a related space (where 'separate objects are similar as pieces of a jigsaw puzzle, some float, some snap together, some overlap') and a related iconography (*England's Glory* match boxes devoured by the Stars and Stripes). In this *Vogue* commission, Bailey's work in New York very much resembled these concerns and pictorial strategies.

His visit also fell at the very moment New York Pop painting penetrated the commercial galleries. That assemblage space composed of commercial lettering, ephemera and detritus, which had been pioneered by Rauschenberg, reinforced the kind of flattened and discontinuous photographic space that Bailey had chosen, a space found in Klein's oblique photographs of Rome and New York.

But it was Pop in its original, proper sense – Pop music, which provided another coding for this photograph. The Twist, the first important dance craze since Rock and Roll, was, Bailey recalls, the single overwhelming cultural fact in New York. Accordingly he looked for ways to combine Jean Shrimpton with that omnipresent image, finding it next to a traffic sign for pedestrians: TWIST; WALK.

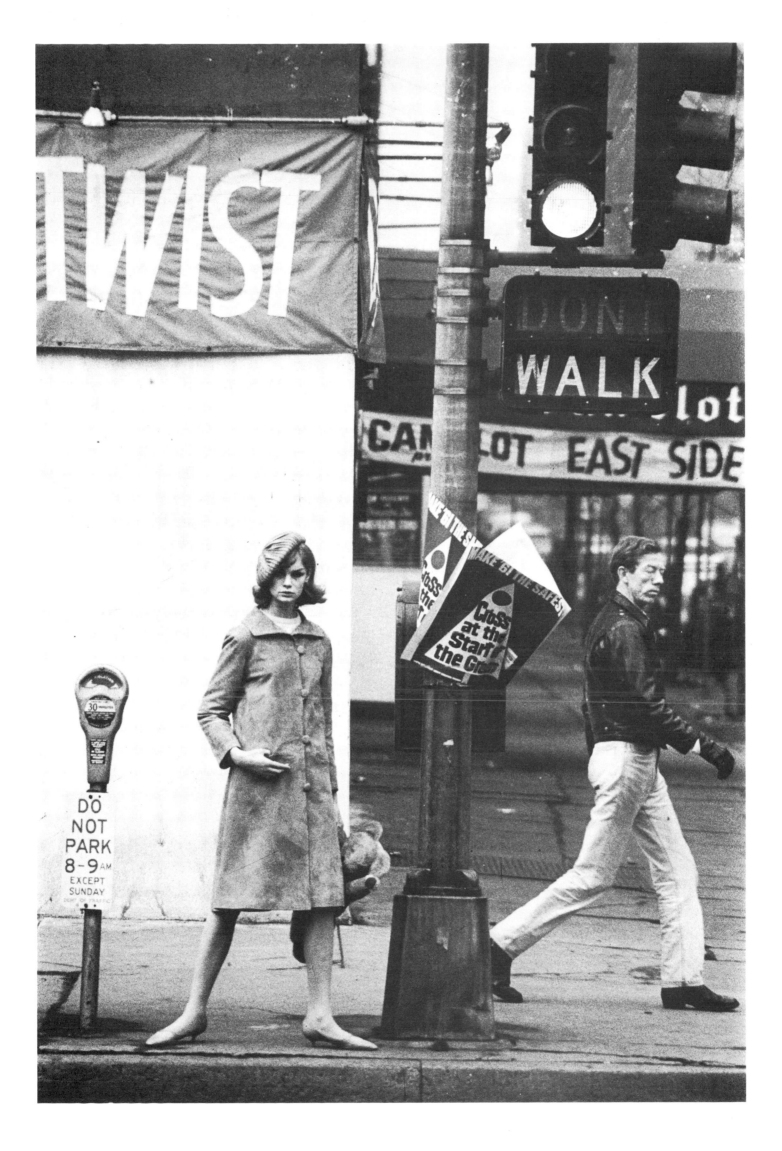

Colin Osman

MARKÉTA LUSKAČOVÁ
b.1944 Czechoslovakia, British
Sleeping Pilgrim, 1967–1970
Ph. 1680–1980
22·2 × 32·1 cm

My first choice is a photograph by Markéta Luskačová, a personal friend who I first met in 1971 in Prague, where she was then living, and who has become one of the major photographers working in Britain today, an associate member of Magnum and indeed a photo-journalist whose work demands far greater recognition than it has already received.

Markéta was born in Prague in 1944 and from 1962 to 1968 was a student of social science at Prague University, where she prepared her thesis (illustrated by her own photographs) on traditional forms of religious faith in Slovakia. During the latter part of the period 1965–69 she took some of the technical courses on photography at the Academy of Film and Fine Arts, Prague. In 1969 she was elected to membership of the photographers' section of the National Union of Artists and the following year won the Union's annual scholarship.

This picture comes from the work done in that period and was first seen at a major exhibition of hers, *Pilgrims*, shown at the Theatre Behind the Gate in Prague, when Prague was still spring-like. I saw the pictures there and they were reproduced later that year in *Creative Camera*, their first major presentation in the West. In one of those pictures, *Helping An Old Pilgrim To His Feet*, is a younger man with a Hasselblad. It is her old friend, Josef Koudelka, and because of Koudelka's interest in central European gypsies and of her interest in central European peasant life some people have seen a relationship between the work of the two, but both she and Josef would be the first to point out that she has ploughed her own often lengthy furrow with a dedication and determination which both of them share.

Since coming to this country as a British citizen she has worked on many assignments, some of them self-imposed, and she was at one time based in Newcastle and a familiar figure at the Side Gallery. Surprisingly enough, she has never had a major exhibition in this country, although it is long overdue.

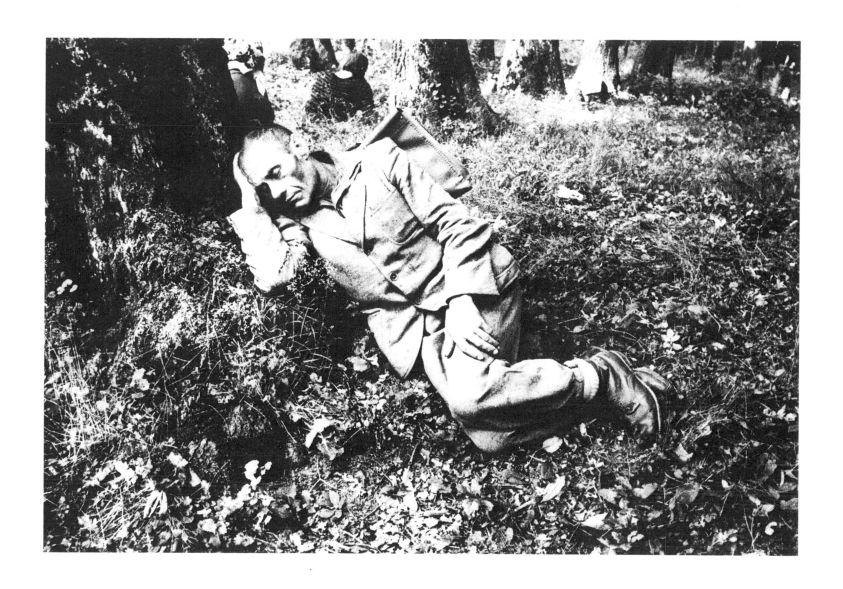

Colin Osman

ANDRÉ KERTÉSZ
b.1894 Hungary, American
Satiric Dancer, 1926
Ph. 210–1976
24·7 × 19·5 cm

If Markéta Luskačová's work arises triumphantly out of the Czech tradition, so too does that of André Kertész, fifty years her senior, arise out of the Hungarian tradition. While there may be similarities between the two traditions, they are alien in every sense of the word to the British and American tradition. André Kertész will soon be 90, and it is more than 55 years since he moved from Budapest to Paris. Now living in New York, he still takes pictures like a Hungarian. It is in his blood and what is strange is that he, the greatest of an extraordinary crop of Hungarian photographers, although producing works of genius, should still be so involved with the Hungarian tradition.

The picture chosen is called *Satiric Dancer*, which is obviously a term that loses something in translation. She was perhaps a cabaret dancer, except that in the West the cabaret has been down-graded to a sexy nightclub show. Perhaps a fairer idea of her talent would be to call her a performance artist at an intellectual cabaret of the sort then common in Germany, Hungary and Central Europe in general. Her name was Magda Foerstner and Kertész first met her when he was still in Budapest. Later she came to Paris and they met again in 1926/7 when this photograph was taken. Kertész has said that the first shots that he took were a little grotesque, though when she had relaxed a little he took the picture that has become famous. Many years later in 1969 it was used on the cover of *Creative Camera* at the time when many of Kertész's early negatives were being rediscovered. Some ten years later Magda Foerstner visited Kertész in his New York apartment. On the same sofa from Budapest the scene was recreated with one minor difference – in Magda's fingers was a copy of *Creative Camera*. It was a personal picture intended as a souvenir for two old friends and I am happy that *Creative Camera* participated as well.

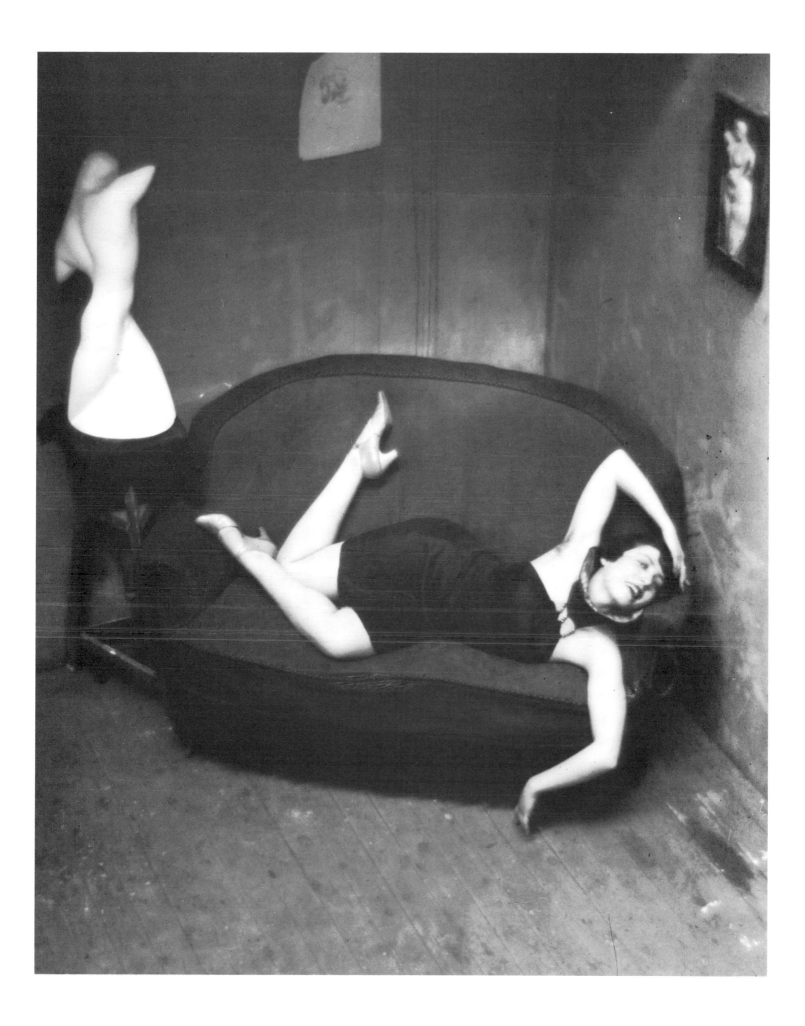

Tom Picton

MAX YAVNO
b.1911 American
Muscle Beach, 1949
Ph. 381–1982
20·2 × 34·3 cm

Like all great photographs, these are both celebrations. The world as theatre. Max Yavno's *Muscle Beach* in Los Angeles. Roger Mayne's *Southam Street* in North Kensington, London.

Max Yavno first photographed backdrops for the Federal Theater Project, part of the New Deal's Work Projects Administration. (The negatives are now in Washington.) Even his famous picture of the men moving the San Francisco tram shows the scene shifters. His photographs are proletarian dramas.

Muscle Beach is the most complicated of his photographs. It is full of exuberant activity, the couple in the middle stand in for the spectator. It was taken in 1949, when you could still write about the Common People without embarrassment.

For all its air of happenstance, *Muscle Beach* took Max Yavno three Sundays and seventy sheets of film. It was taken for a book on Los Angeles after a friend suggested going to Muscle Beach. It is a very considered photograph, with the large format camera locked to a tripod. On the back are elaborate printing instructions – the bright light of the beach and the high contrast of the negative made this difficult. It is like some particularly well-subsidised production by the local community theatre.

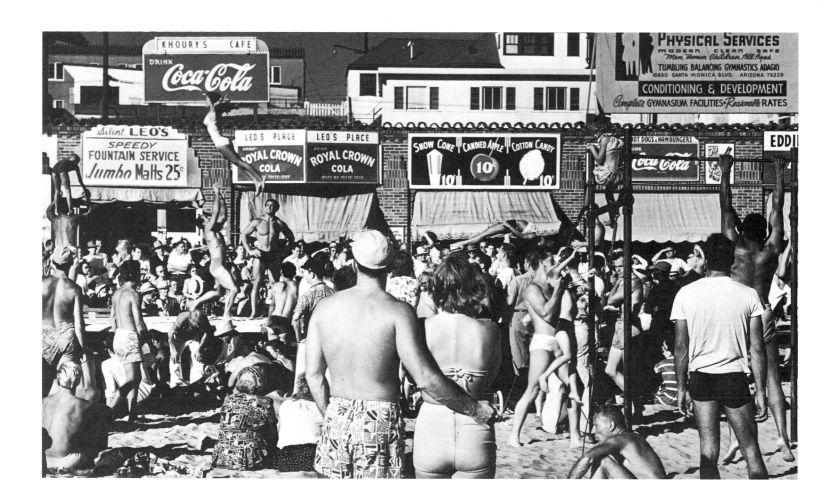

Tom Picton

ROGER MAYNE
b.1929 British
A Page from the Southam Street Album, 1956–61
Ph. 277–1978
36 × 54 cm
Given by the photographer

Roger Mayne is a romantic. His album and this photograph celebrate the life and games in Southam Street, a play street in North Kensington, London. He found the street and its people beautiful. The photographs were taken between 1956 and 1961 when British intellectuals were venturing into the foothills of working-class culture. (Richard Hoggart's *The Uses of Literacy* appeared in 1957.)

Fifty-six of the eighty photographs in this album were published in Theo Crosby's *Upper Case*, an influential and short-lived cultural magazine. They were taken on a camera which produced 6 × 4·5 cm negatives – 16 on a 120 film. The contact prints, which Roger Mayne also gave to the Museum, are decisive. He took only one shot of all the best and most dynamic photographs. Today, when photographers take thirty-six or more shots to produce one print, such economy is refreshing. It is like the great artist drawing a line with a single stroke and not pecking at the paper.

Southam Street has been compared to a Victorian album. The intention was different. Roger Mayne's volume was a 'dummy' for a book which it became in a shorter and improved version in *Upper Case*. It was not only a collection of photographs. The pictures are laid out to provide pace and variety. More Victorian are the twenty albums showing family holidays and trips abroad which Roger Mayne has produced since.

Both photographers had short periods of incandescence. Max Yavno took fine photographs before and after a commercial career. Roger Mayne worked for a decade before virtual retirement into private life. Such mercurial creativity is a common pattern: Walker Evans's *Let Us Now Praise Famous Men*; Robert Frank's *The Americans*; even Cartier-Bresson's early work.

Circumstances take photographers away from their beginnings. Southam Street has been demolished. The motor car has made street games lethal. Roger Mayne now lives in Dorset. Ten years after this photograph he took another picture that was much the same. It shows his family and friends enjoying summer with their children in a cottage garden. It is all part of the long retreat into domesticity and privacy.

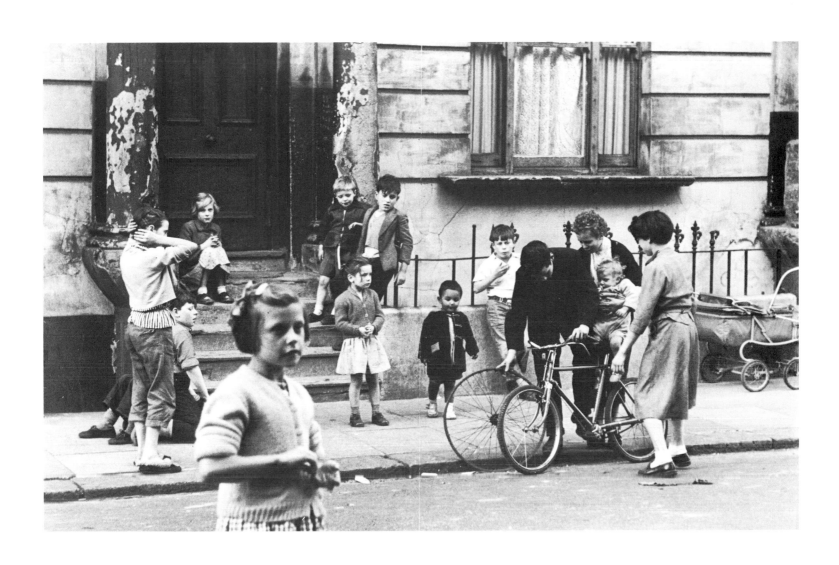

Anthony Quinton

ANSEL ADAMS
b. 1902 American
Mount Williamson, Sierra Nevada, from Manzanar, California, 1944
Circ. 595–1975
55·8 × 71 cm

Ansel Adams and Diane Arbus, two great American photographers of this century, are in some ways at opposite extremes. In Adams's visual world human beings, and even the products and effects of human beings, are largely absent. His main subject-matter is natural objects, sometimes comparatively small – flowers by the roadside, a group of birch trees gleaming against the darkness of a wood, a snow-laden oak in Yosemite, but more usually great expanses of landscape, mountains above all, variously cumbered with forest, snow, water and cloud. Even when there are human products in these great scenes they are minimal or vestigial. The buildings in his famous picture of *Moonrise at Hernandez* are much like the abandoned rock-dwellings of the Canyon de Chelly, that recurrent subject which he inherited from Timothy O'Sullivan. But when he does photograph a human subject the result is sometimes almost Arbus-like, as with the anxious, lumpish girl in her graduation dress, in Yosemite valley, graduating far from standard, populous Middle America, or the gnarled and wrinkled woman looking suspiciously at the camera through a screen door.

The world of Diane Arbus is almost too human. She concentrates on weird, marginal, pathetic people, on dwarves, freaks and halfwits whose painfully exaggerated possession of some human characteristic excites a characteristically human pity or dread. But neither is at all an illusionist or impressionist. Both strive for the sharpness and clarity to which Adams was converted by his coming to know the photographs of Paul Strand.

Adams's *Mount Williamson* combines the prehuman remoteness typical of his landscapes with a theatrical vigour that is peculiar to it. It is as if we were privileged to watch a fairly early stage in the creation of the world, mid-morning on the third day, perhaps, that on which God said, 'Let the waters under the heaven be gathered together into one place and let the dry land appear: and it was so', at a moment when the creator is taking a short break from his labours. The great boulders in the foreground seem to be about to roll forward to crush us. Something mysterious and terrible is in preparation in the clouded region between the two peaks at the upper limit of the boulder-strewn plain. By its invocation of the majesty of nature this photograph is calculated, more than almost any of his works, to evoke that 'cosmic piety', that sense of the comparative minuteness of humanity in the whole scheme of things, which Santayana believed to be a part of the rational essence of religion.

Arbus's naked couple are less painful than most of the human oddments on whom she fastened. Curious, rather than pitifully grotesque, they excite less obvious reactions than her more typical works. There is a large industry manufacturing photographs of people with nothing on. But in the soft pornography of girlie magazines and some commercial advertising only young and beautiful bodies are shown. This well-covered, and in some respects sagging, couple in their late fifties or early sixties arouse an interest left unaffected by the postures of Marie Helvin or the Page Three girls of *The Sun*. They can look calmly at the camera because they are nudists, accustomed to being undressed in public. The TV set between them seems almost prudishly over-dressed. What happens next? In hot weather have they a tendency to stick to their seats? Does their lack of bodily concealment have an anaphrodisiac effect on them? They have an engagingly well-satisfied look which suggests that it does not.

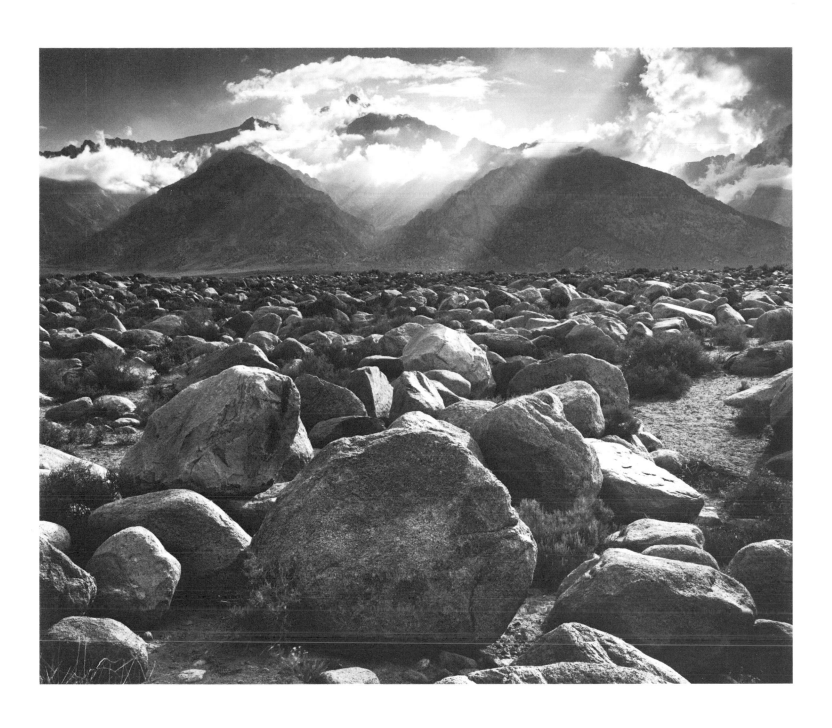

Anthony Quinton

DIANE ARBUS
1923–1971 American
*Retired Man and his Wife at Home in a Nudist Camp One Morning
in New Jersey*, 1963
Circ. 308–1974
36·5 × 38 cm

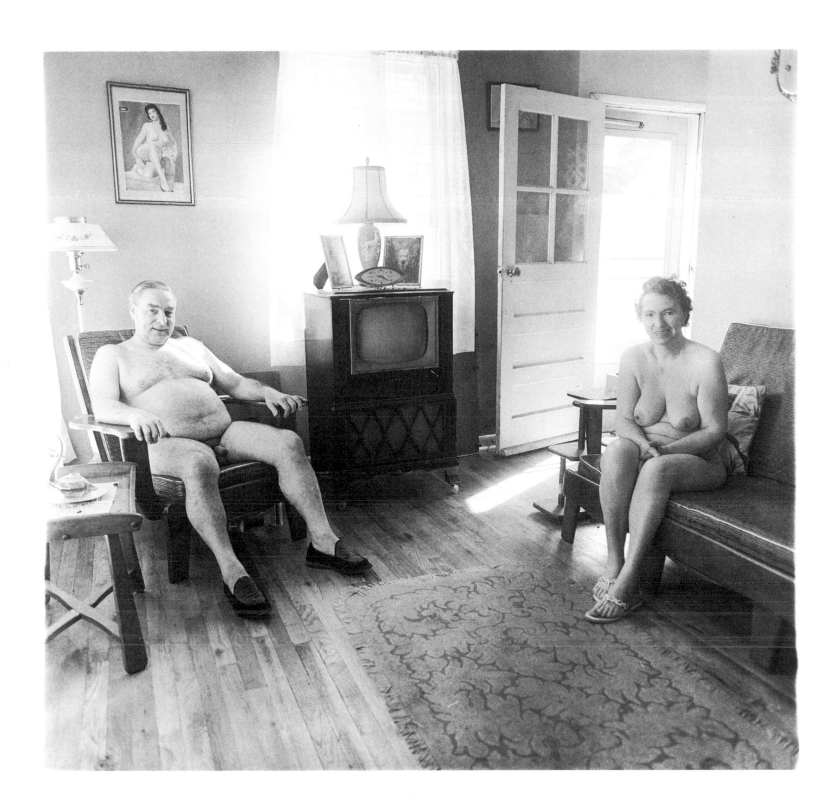

Aaron Scharf

ANONYMOUS PHOTOGRAPHER
for Topical Press
Olympic Games Sensation, 1908
11–1965
24·5 × 28·7 cm
From an album produced and presented by Ilford Ltd

I remember coming across this photograph in the V&A collection about fourteen years ago. It has long stuck in my mind. Not only does it record an extraordinary event in the history of sport, but it seems to me to address the feelings in a profound way. Something so urgent is conveyed in the expressions and gestures of each participant. The photograph's impact is immediate and evokes strong sympathies. The compositional nuances, intuition probably enhanced by accident, contribute much to the drama of the event. Without the story the photograph still triumphs. With it, the image becomes even more indelibly fixed in the memory. Here, form and meaning are reciprocally reinforcing.

The story? Dorando Pietri was the first to break the tape in the Marathon Race of the fourth modern Olympiad held in London in 1908. But he didn't win! He arrived at White City Stadium well ahead of the other contestants after a gruelling race of more than twenty-six miles, starting from Windsor Castle. Dazed, in a state of complete exhaustion, Dorando entered the stadium and ran the final lap around the track. Just fifty yards from the tape he collapsed; he got up, staggered and twice more fell. The crowd was on its feet shouting its support. Officials surrounding Dorando frantically urged him on. Almost blind with fatigue he struggled up, once more to fall – only ten yards from the finish line. He managed somehow to get to his feet in a last, desperate, attempt to reach the tape. The spectators and officials, wild with enthusiasm and ruled by this momentary passion, helped him across the line – that telling split-second shown here. Because of this Dorando was disqualified. The American, J.J. Hayes, thirty-two seconds behind Dorando, was declared the winner.

But the pluck of the twenty-two year-old confectioner from Italy won the esteem of the British public. It all had a happy ending. The Queen presented him with her own gold cup. He appeared at the Oxford Music-hall, after a Bioscope film showing of the race, to give a cheering audience his thanks in Italian. Every night for a week Dorando took his bows on the stage of the Tivoli. And on his return to Italy he was given a hero's welcome.

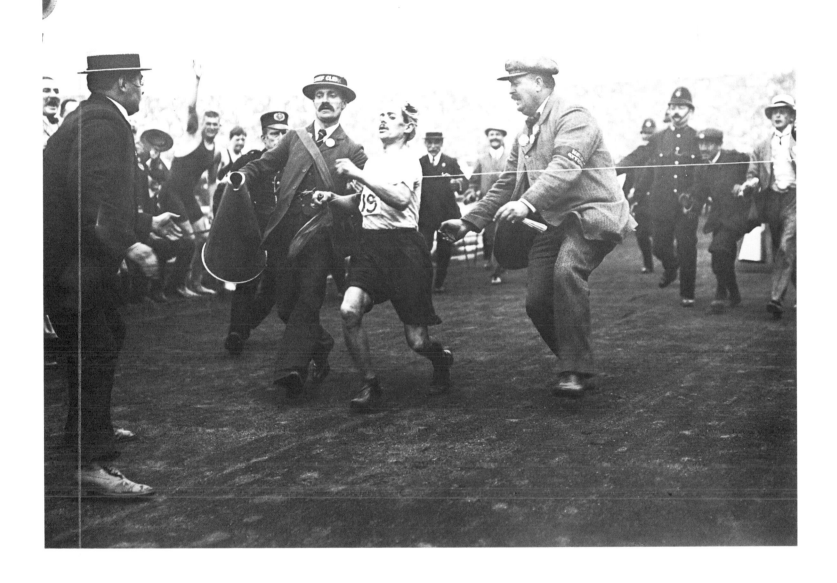

Aaron Scharf

EUGÈNE ATGET
1857–1927 French
*Church of St Gervais, Paris c.*1900
Ph. 224–1903
21·1 × 16·7 cm
Albumen print

Unlike the Dorando Pietri photograph, Atget's many views of courtyards and closes, narrow alleys and streets, do not elicit an immediate response. They require contemplation. They promote reverie. Typical of a whole *genre* of street photographs in Atget's work, this one, of a hidden precinct around St Gervais, enchants me with its great sense of quietude. It is so much at odds with what we know was a bustling city of Paris at the time. The space in such photographs is almost always circumscribed, a serene refuge from the noisy world outside, secured by dead ends: walls or gates or opaque shadows and the narrowest of passages which seem reluctantly to lead one out of Atget's enclaves.

In this photograph a feeling of stillness is enhanced by the absence of people, yet the marks of human use are everywhere discernible. The worn paving stones, the weathered graffiti, the flaking paint and eroded buildings conjure up echoes of times past. One is drawn inexorably into the picture by the attenuated perspective, held there by an apparently impenetrable exit.

Atget's themes, always done in series, reveal an obsession with the life and death of the city. Though some of his photographs show the construction of new buildings, his heart is not in the speed and *charivari* of the modern metropolis. He muses on its decay. In such photographs as this, one senses an impulse in Atget to rescue these old buildings and streets from oblivion. The camera is his instrument. His series of close-ups of ancient doorways, weathered wood and fittings, of lanterns and gargoyles, fountain-heads, old wagons, old clothes, pots and pans, rags even, appear to me not so much simple description or nostalgic recording, as the realization, in these strange and highly focused details, of the imagery of dreams.

Often, in Atget's cul-de-sacs only vestigial forms of the human presence remain. It is as though people too, like the buildings and paving stones, have suffered the ravages of time. Is this merely an aberration of the large plate camera and long exposures? I cannot believe that. To my mind, the technical conditions must have provided Atget with eloquent means for commenting on the fugitive character of existence.

Chris Steele-Perkins

DONALD McCULLIN
b.1935 British
Twenty-four year-old Mother with Child Suckling Empty Breast, Biafra, 1969
Ph. 1315–1980
38·8 × 25·6 cm
Given by the photographer

It is important that the Victoria and Albert Museum has Don McCullin's photographs well represented in its collection. They hold more of his photographs than any contemporary photographers other than Bill Brandt and Henri Cartier-Bresson. The experiences of war and suffering as interpreted through sensitive photography must be rigorously represented in any major collection that wishes to preserve the significant.

This mother and child were photographed in 1969 during the Biafran war. The British Labour Government were supplying arms to the Government of Nigeria on the pretext that if they did not supply them, somebody else would. The arms were used ruthlessly to put down the attempt of the Ibo people to establish independence from Nigeria in their own country: Biafra.

The picture appeared in the *Sunday Times* with the caption: 'A twenty-four year-old mother suckles her child. Kwashiorkor, the disease bred of starvation, has been renamed "The Harold Wilson Syndrome" and is entered as such on Biafran death certificates.' Later it was used as a poster by *Sunday Times* journalists to expose British involvement in the conflict.

A picture like this can be a collaboration between the photographer and subject in as much as the subjects, aware of the power of the media, offer themselves as examples, symbols, of a condition they believe may be positively influenced by such exposure. The best of these images outlast their immediate journalistic purpose and represent a pinnacle of photographic achievement in this genre without losing their emotional impact. This image still, fourteen years later, comes as close as any that I am aware of to connecting the viewer to the tragedy, and dignity, at the torn edge of human suffering.

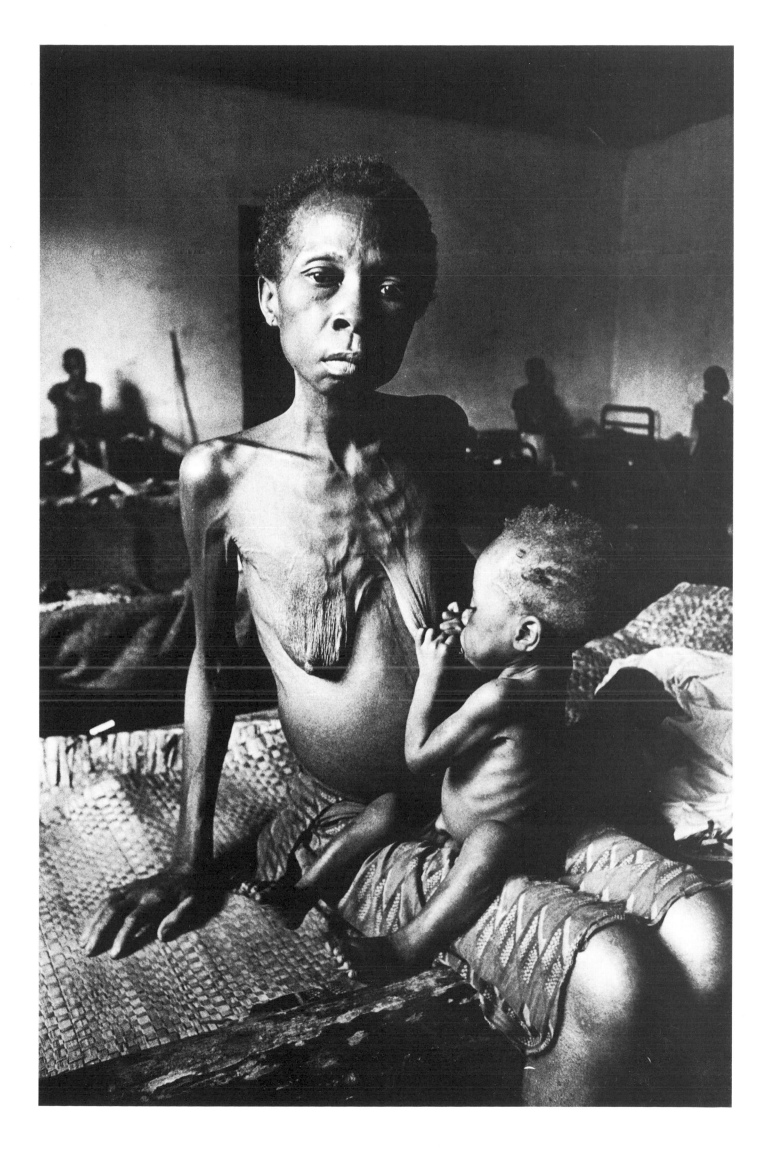

Chris Steele-Perkins

JOSEF KOUDELKA
b.1938 Czech
Straznice, 1965
Circ. 522–1976
23·2 × 35·3 cm

I have always found this one of Josef Koudelka's most arresting images: images which are some of the most profound to have been produced by photography.

The photograph comes from his book *Gypsies* published in 1975. The sixty photographs in the book are selected from work done mainly between 1962 and 1968 documenting gypsy life in Eastern Slovakia.

While at one level he explores different territory to McCullin, Koudelka's photographs are also frequently about primal aspects of the human condition. This fact is best expressed by John Szarkowski in his introduction to the book.

Josef Koudelka's photographs aim at a visual distillation of a pattern of human values: a pattern that involves theatre, large gesture, brave style, precious camaraderie and bitter loneliness. The pattern and texture of his pictures form the silent equivalent of an epic drama.

Koudelka's pictures seem to concern themselves with prototypical rituals, and a theatre of ancient and unchangeable fables. Their motive is perhaps not psychological but religious. Perhaps they describe not the small and cherished differences that distinguish each of us from all others, but the prevailing circumstance that encloses us.

Apart from religious festivals and street life, photographing the European Gypsies has been a major part of Koudelka's work for over twenty years. For him they are far more than photographic subjects, they are an integral part of his way of his life, friends and companions.

The music, indispensable to the gypsies, is important to Koudelka, who has a collection of tapes – frequently recording from his pocket while he is photographing. The picture is strangely ambiguous about the music: its importance is emphasized by the three thrusting figures and the holding gaze of the central figure, yet the audience seems concerned with an event beyond the frame of the picture and ignores the musicians. Perhaps these different levels: foreground, background; active, passive; attentive, distracted, contribute to the picture's particular resonance.

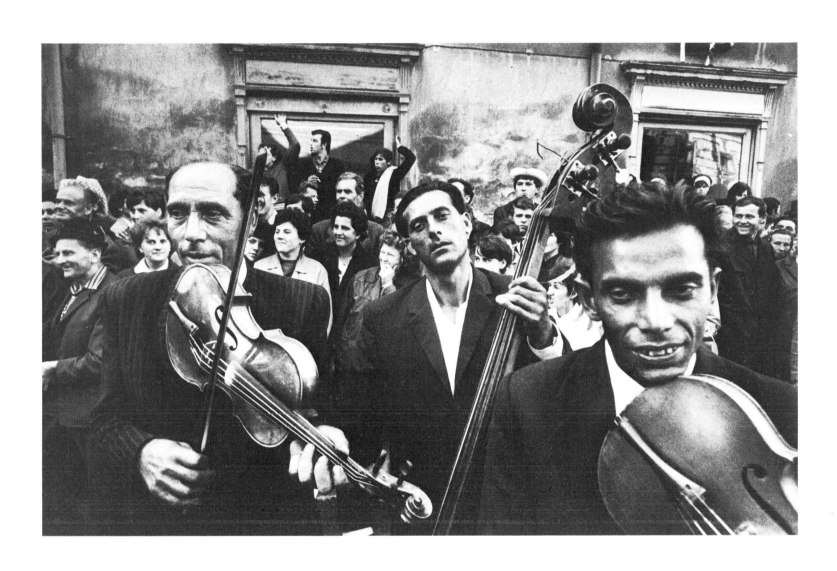

Caroline Tisdall

CHRIS STEELE-PERKINS
b.1947 British
Shattered Portrait of Dead Palestinian in Cemetery near Beirut, 1982
Ph. 365–1982
33·9 × 22·7 cm

The traditional 'coup' in war photography is the *significant moment*, the moment of death and drama caught by a photographer in the right place at the right time. These are the images which become universally known, and some of them will be brought to this exhibition by almost every visitor: the death of a republican in the Spanish Civil War, the moment of execution of a prisoner in Vietnam, and so on. The photographer was in at the kill, and thus became, as Roland Barthes put it in *Camera Lucida*, 'the agent of death'.

Just one of the problems with these dramatic images is that they perpetuate the myth of death in war as somehow instant, clean, individual and as heroic as Hemingway. Anyone who has witnessed the misery of modern warfare knows otherwise: death can be slow and collective, the victims anonymous and their number not even known. Such was the horror of Beirut in the summer of 1982 and for me Chris Steele-Perkins captured it in a photograph which is so much a 'still' in a much-filmed war that it becomes an icon. Like an icon it is an image which demands reflection and a certain amount of knowledge. It is a memorial photograph from a cemetery in Beirut of a young Palestinian, one of thousands who have died in a struggle which should have been solved before he was born. Yet in the latest round of destruction even this frail photographic memory of his life was shattered by a bomb, leaving a still face staring out from beneath a splintered surface.

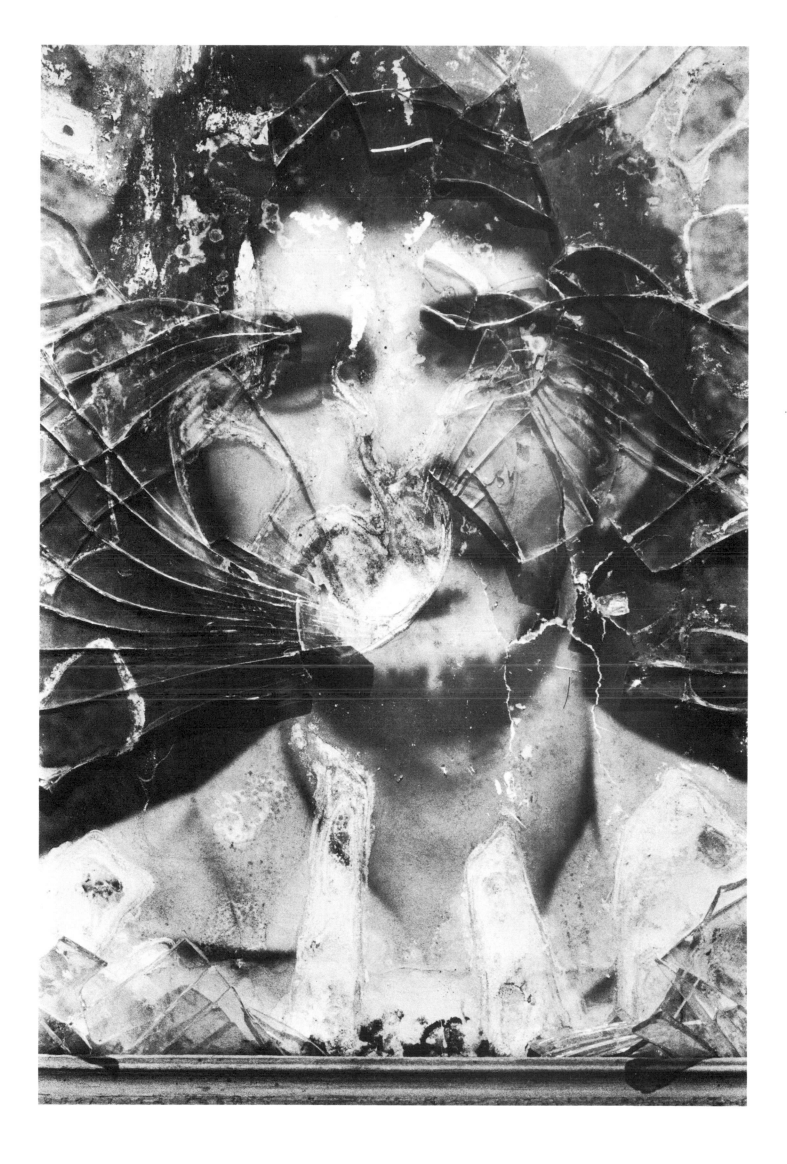

Caroline Tisdall

JOHN DAVIES
b.1949 British
Scafell Pike, towards Great Gable, Cumbria
Ph. 364–1982
26 × 34·5 cm

It may say something about (my own) human duality that the only companion I could find for a memorial is a mountain. I find myself responding to John Davies' portrait of Scafell through a process of recognition which again depends on the relationship between surface and texture, and the passage of time. The mountains you knew as a child are frozen in the timelessness of an innocent cliché. When you return to them they are always metaphors in which innocence resumes its place alongside experience. It's something you rarely recognize in landscape photography. Sometimes it's the blandness of the photograph that gets in the way, or the drama, or the exoticism. But for me in John Davies' vision it's all there: the timelessness of smooth slopes from time immemorial, the rough fragments of rock still decomposing, and the innocence of a path trod by transients which wends its way between them.

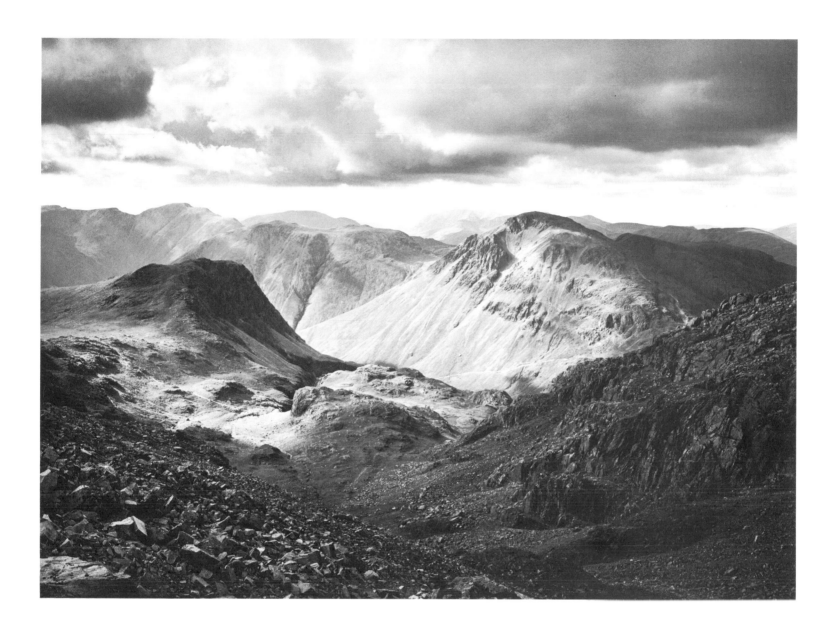

Peter Turner

WALKER EVANS
1903–75 American
Penny Picture Display, Savanna, 1936
Ph. 182–1977
24 × 20 cm

Walker Evans and Lee Friedlander stand like a father and son in the tradition of photography. Their work adds up to a quiet, sometimes subversive compilation of the commonplace that can be properly termed 'Transcendent Documentary'. With Friedlander's finely-understated skill coupled to a sense of adventure in picture-making, this young photographer picked up the same scents that an older Evans had been sniffing after for years. They shared a fascination; they loved what was typical. In picture after picture both can be seen to have stalked the particulars of their environment. Instinctively they sought the fact of the matter and then made this the matter of their pictures. What distinguishes their work as artists, however, lies in their individuality. As Evans once said, *'The secret of photography is that the camera takes on the character and personality of the handler.'*

In personality, Evans and Friedlander are as different as their ages would suggest. In character they shared a sense of intelligence and culture that informs their work; giving it an edge, lending lyricism to the urban landscape they pictured. In their different ways both too have explored the transformation that can take place when what is photographed becomes a photograph. More often than not, the subject matter they chose to record had no overt pictorial appeal. What was of concern to the late Walker Evans and remains a hallmark of Lee Friedlander's work is a reaching for the act of finding, seeing and making images. And in photographing photographs as they both have here, the object to be photographed and the objective of their photography become one.

Evans's picture has been described as a short catalogue of American physiognomy. A kind of visual roll-call that delights in variation, finds poetry in contrast and harmony in the whole. The work has humour and sadness. Like so many of his pictures this one touches a nerve of puritan honesty that interrupts its serene formality. 'All these people had posed in front of the local studio camera,' Evans said, 'and I bring *my* camera and they all pose again for me.' Within this serried row of provincial faces, made small enough to seem anonymous, there lies a sense of *corporate* American identity; but each image still makes its own contribution to the whole. Overlaid is that word – STUDIO. Evans knew how to give lie to the motions of objectivity his medium encourages; and how to make incisions into our pre-conceptions about reality. He let the fact of a *photograph* creep in.

It is no accident that Lee Friedlander recognised a similar opportunity when he found these photographs to photograph. His style, of course, is different and personal, his vision sometimes more mysterious though just as street-wise. But he shares with Evans some important gifts. Among them are conviction, precision in seeing and taking, assurance, humour and sadness. Finding Midnight Starr and Ginger Gale cheek by jowl – if that's the phrase – with LBJ and Hubert Humphrey must have seemed a wonderful offering; as casual an arrangement as any patriotic entrepreneur might use to combine his love of country with a chance to advertise, and all arranged with the same unintentional directness that Evans found in his picture. As a comment on the state of the nation it is paradoxical, somewhat sad and very amusing. As a comment on the state of his art it retains all these qualities, brought into the image with himself. There is no mistaking the photographer's own reflection. And, as in Evans's picture, there is an understanding shown here of a very reflective art.

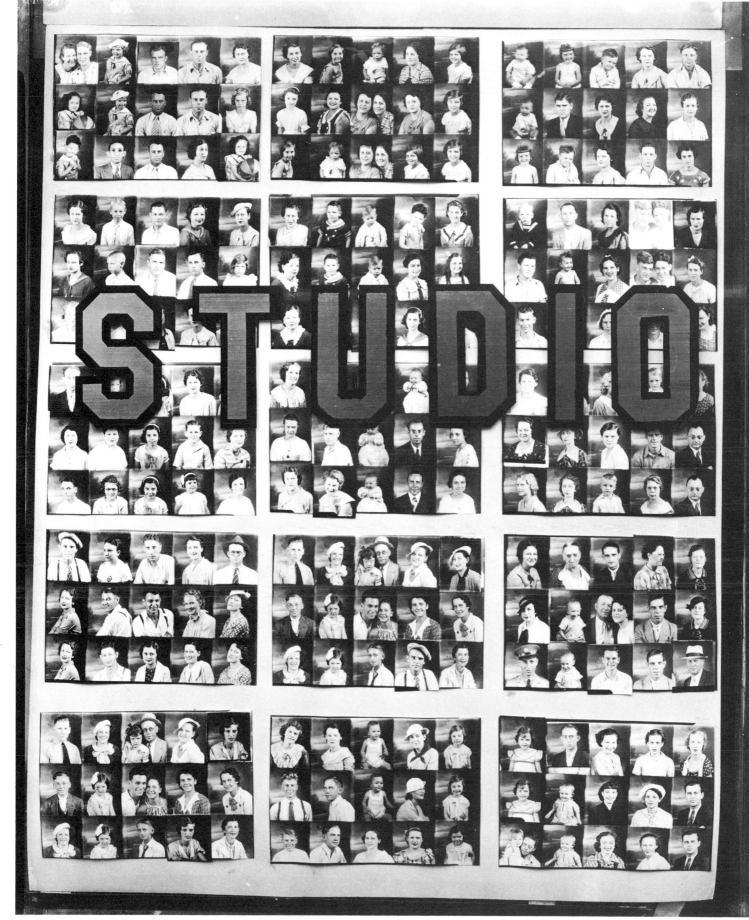

Peter Turner

LEE FRIEDLANDER
b. 1934 American
Tampa, Florida, 1970
Ph. 774–1980
19 × 28·3 cm
Given by the Gordon Fraser Charitable Trust

Some years ago Walker Evans was asked to write on the nature of quality in photography. He was a literate man and wrote with tremendous style, ending his piece with a succinct denouement . . . 'Leaving aside the mysteries and inequities of human talent, brains, taste and reputations, the matter of art in photography may come down to this it is the capture and protection of the delights of seeing; it is the defining of observation full and felt.' To the delights for a photographer in 'seeing' must be added the viewers' pleasures in looking. In this case at works by two remarkable photographers. Walker Evans and Lee Friedlander are men who have lived by their eyes. And like their spiritual forefather Eugène Atget, their work sings through those eyes. The song is one of recognition, excitement, stimulation, awareness. It has a smile and a sting. I couldn't ask more from a good photograph – or any other work of art.

Marina Vaizey

DOROTHEA LANGE
1895–1965 American
White Angel Breadline, 1933
Ph. 371–1982
12·4 × 10·1 cm
Exchange with the Oakland Museum, California

Unlike many of the other arts, a significant number of the greatest practitioners of photography have been women. Dorothea Lange's own life and career epitomize difficult dualities in both personal and professional terms. She was both wife and mother and travelling photographer, deeply aware of the personal price she might have to pay for relinquishing domestic responsibility, which she did not only for professional reasons but also through economic necessity.

Lange had served an informal apprenticeship in several New York City studios of photography before embarking with a friend on a trip round the world which came to a permanent halt in San Francisco. Soon she opened what was to be an intermittently successful commercial portrait studio. On her darkroom door, she put up some lines from Francis Bacon, about the nobility of 'the contemplation of things as they are'. She had realised, too, that what she most wanted to do was to photograph people. But there was a tension between the commissioned portrait which after all provided her family's livelihood and her increasing desire to photograph, intently, what she wanted, in the street life of San Francisco.

It was the time of the Depression. In 1932, Lange went out one day, accompanied by her brother Martin, to photograph the local bread-line, which she had often observed. The rich woman who paid for it was known as the White Angel. One of the several photographs Lange took that day, of an old man looking down, cradling a tin cup, unaware of the photographer's presence, is one of the handful of images, extremely widely reproduced, that has come to stand for the entire complex of causes and effects of those times. Interestingly, it was her assistant who developed this photograph and drew this image to Lange's attention; she put it on her own studio wall, interested in visitors' reactions, and always included it in any exhibition of hers over which she exercised selection and choice. It was a favourite of Lange's, for it symbolized to her her first steps outside to take those photographs, which moved from showing people in the posed isolation of the studio to people in real life, in their own situations.

It is a dignified photograph. As she put it herself,

I knew I was looking at something. You know there are moments such as these when time stands still and all you do is hold your breath and hope it will wait for you.

She felt strongly that her inner sense had told her then that she was not 'taking anything away from anyone, their privacy, their dignity, their wholeness'.

But *White Angel Bread Line* is a paradoxical success. The image contains information which is readily accessible; our own cultural conditioning now would tell us without benefit of caption or written information that this is Depression America, that the man facing towards us – although not looking at us – is poor, has been longer poor than the others, probably old, but perhaps old before his time, and wrapped in an isolation that is acting as a method of anaesthetizing him from a painful place and time. He is by his own chosen stance isolating himself from the crowd of other men.

Yet the photograph holds us, has become a 'classic' because of the way in which it is composed. There is the subtle diagonal of the barrier on which the man is leaning his body; his own light hat and face, contrasting gently with the sea of dark clothes and hats behind, makes him the central figure not only because of his placing in the photograph, but because of the convention to which we are accustomed in Western religious painting, in which light headgear (haloes, crowns) indicate the major 'good', 'holy', characters. The picture is thus formally beautiful, an asymmetrical balance of light and dark. It is also devastating, but it is its calm, even elegance that transcends the subject matter. Photography is often unable to avoid making beautiful scenes of desolation and despair.

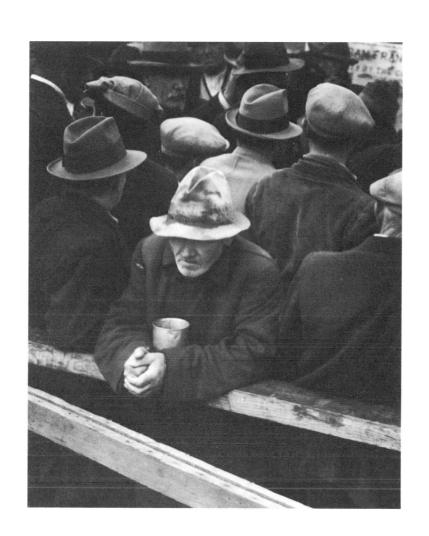

Marina Vaizey

ALFRED STIEGLITZ
1864–1964 American
Equivalents, 1927
Ph. 366–1982 and Ph. 367–1982
11·8 × 9·2 cm

John Constable said – and indeed practised – that there was not 'a class of landscape in which the sky is not the key note, the standard of scale, and the chief organ of sentiment'; the English poet Gerard Manley Hopkins praised God for dappled things. In an English context, both sentiments come to mind and eye when looking at Alfred Stieglitz's cloud studies, photographs which he was to subsume in an area of his work he called Equivalents, controversial in his lifetime, controversial now. Small, beautifully printed photographs in which their subject matter almost but not quite vanished, and the spectator sees a progression, shifts of emphasis, movements of light: we recognise light, because of the dark. 'Light! Light! A photograph is nothing but light', Stieglitz said.

His own activities as a dedicated entrepreneur for the images – photography, painting, drawing, sculpture – of his own times which he regarded as most vital and significant; his participation in the Photo-Secession, the foundation of Camera Work, the proprietor of '291' and subsequent galleries, the crucial collector of photography whose own collection graces several of the most important museums in America, the lover, husband and photographer of the painter Georgia O'Keeffe, the exhibitor in America of artists from Europe as diverse as Matisse, Picasso, Rodin and Brancusi, of photographers from Baron de Meyer to Paul Strand to Ansel Adams . . . Stieglitz has a pivotal place in the arts of America. He himself epitomized the movement from pictorial to straight, pure photography, his own attitudes the inspiration, mirror and catalyst of changing times.

From 1917 to 1946 Stieglitz spent most of his summers at Lake George in Upper New York State; in the 1920s he spent almost half the year there. It was the clouds of the country sky that he photographed, waiting, patient as a stalker, for the exactly appropriate moment, when what he saw and observed – the outer world – matched in some inarticulate yet visible way what he felt – the inner world.

'My cloud photographs are equivalents of my most profound life experience, my basic philosophy of life.' Feelings into form. He wanted to show that the quality and meaning of his photographs were not to be found directly in their ostensible subject matter. Clouds, too, were available – to everybody, if they had eyes to see, minds to understand, and hearts to feel. Clouds required no privileged access. His exhibition in 1924 was called *Songs of the Sky – Secrets of the Skies as revealed by my Camera*. The Secrets were of course visible to all. The simple verbal language Stieglitz used to describe his purpose, aim and hopes for Equivalents – his enthusiasm – embarassed some of his more tough-minded friends. But the photographs are not sentimental.

With the cloud studies, Stieglitz shows the creativity of photography – different from that of painting – in selecting and taking. He portrays pure form, pure sensation, felt and apprehended on two levels. We may recognize the subject, dappled clouds, reacting as we do so to the feelings we have for sunset, sunrise, twilight, moonshine, the cycles of the sky, with their punctuation of sun, moon, star and cloud, and the symbolic values with which we invest our vision of the sky.

But with these photographs Stieglitz wanted to aspire to the condition that music may create, too: an abstraction, the 'pure' sensations of light and dark, in which the outward observed form matches, deepens and expresses innermost feelings. The Equivalents work best together, when we may see what movements and changes, what variations in forms, in light, and in dark, what cycles, most moved the photographer.

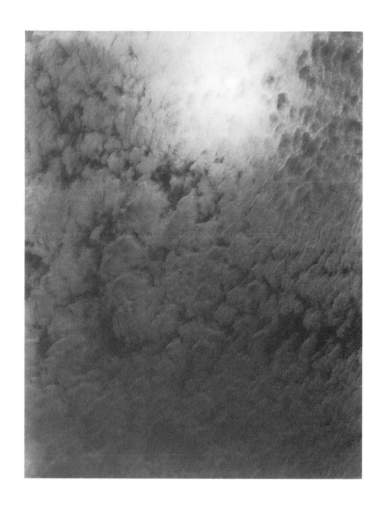

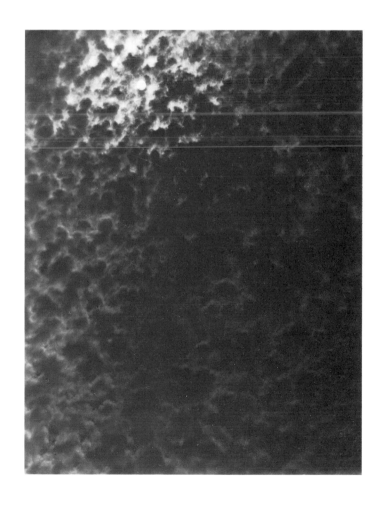

Mike Weaver

PAUL STRAND
1890–1976 American
Blind Woman, New York, 1916
from Portfolio III
Ph. 372–1982
33 × 25·3 cm
Modern print (1975)
Given anonymously in memory of Gordon Fraser
© The Paul Strand Estate 1971

The photographer of Spoon River, in Edgar Lee Masters' anthology, asked himself the question that preoccupies all portraitists:

> *What was it in their eyes? –*
> *For I could never fathom*
> *That mystical pathos of drooped eyelids*
> *And the serene sorrow of their eyes.*

Strand was influenced by *Spoon River* (1915) but there is nothing mystical or serene about his *Blind Woman* (1916). Is that a wall-eyed look or a sidelong glance? Her sinister aspect offers resistance to our world which merely licenses her. It matches Strand's own sneakiness in photographing her on the sly, with a false lens.

The word BLIND appears to name the condition of her eyes – but does it? Such a linguistic sign, to be seen and sounded, strikes us with a sense of hyperbole. Her eyes are damaged, her ears are covered. Yet the word, as sign, and the natural fact of her eyes, as sign, set up a tautology which echoes endlessly between them, until we are hypnotized. Head askew, quiff awry, stone-work and mortar aslant, the picture is, nevertheless, so ordered and well-spaced it seems as if she is both posed and posing doubt. She looks, indeed, askance.

The portrait of the French youth, *Young Man* (1951) is clearly posed. Up against a wooden door, studs in a horizontal line above his head and boards vertical as the highlight on his nose, he is subjected to the four-square, direct approach. And how he stands up to it! In his clean blues, the *tricot* underneath as boyish as his hair is stylish, he is flamboyant: The straight stem of a nose leading up to the sculptured cup of light, his forehead, this is a frontal shot of the frontal bone. The hair flames out to match eyes which blaze back at us – natural fact as sign for the word, TORCH BEARER?

With access to New York City records we could tell what kind of sweated immigrant the blind woman was. A visit to Gondeville, Charente might discover, eventually, whether the youth was the son of *collabo* or *résistant*. With knowledge of Lewis Hine and the Ethical Culture High School in New York, of the Neo-Realist movement in Europe after the War, we could impute a social meaning to these pictures. But Strand's expression has the force of individual appearance, not social reality. By stealth, by fire, these eyes are prehensile and demonic. Neither pathetic nor sorrowful, they affirm the power of human resistance to the social condition. They express a troubled humanism.

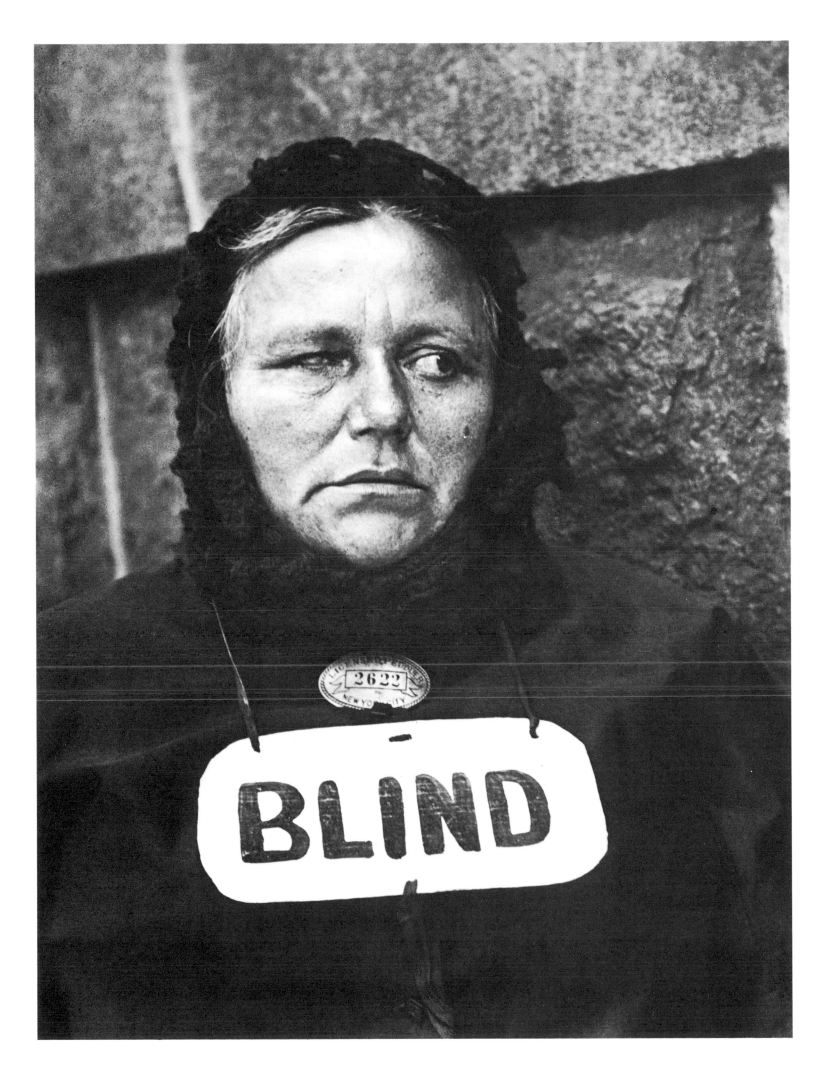

Mike Weaver

PAUL STRAND
1890–1976 American
Young Man, Gondeville, Charente France, 1951
from Portfolio III
Ph. 373–1982
27·8 × 22·2 cm
Modern print (1975)
Given anonymously in memory of Gordon Fraser
© The Paul Strand Estate 1971

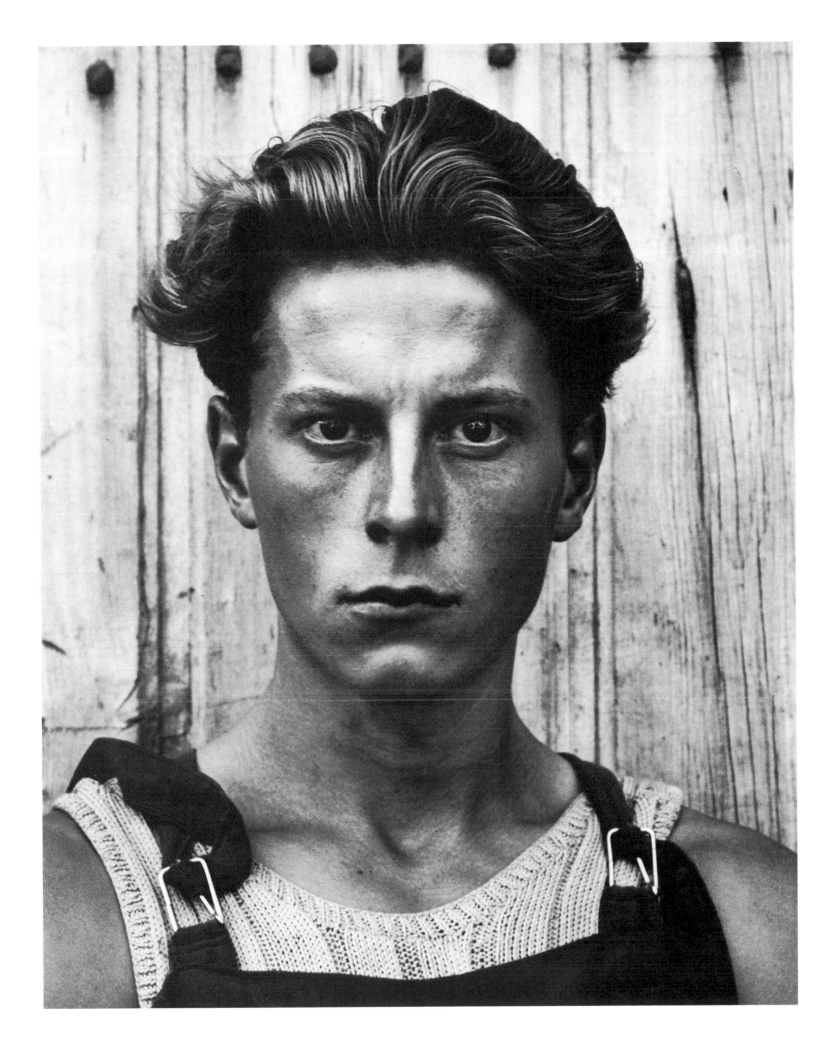

Index of Photographers